Film Actresses

Volume 22

Joan Blondell

Documentary study

Part 1

ISBN-13 : 978-1502981707
ISBN-10 : 150298170X

Dtp
and
graphic design

Iacob Adrian

Author statement

The actors and actresses are the the bricks .

The cast and crew are the plaster .

They stand on the foundation created by
producers and writers and directors .

All these people creates the great palace
of the art of film .

Iacob Adrian - 2013

"I'VE ALWAYS BEEN A DEVIL"

by JEWEL SMITH

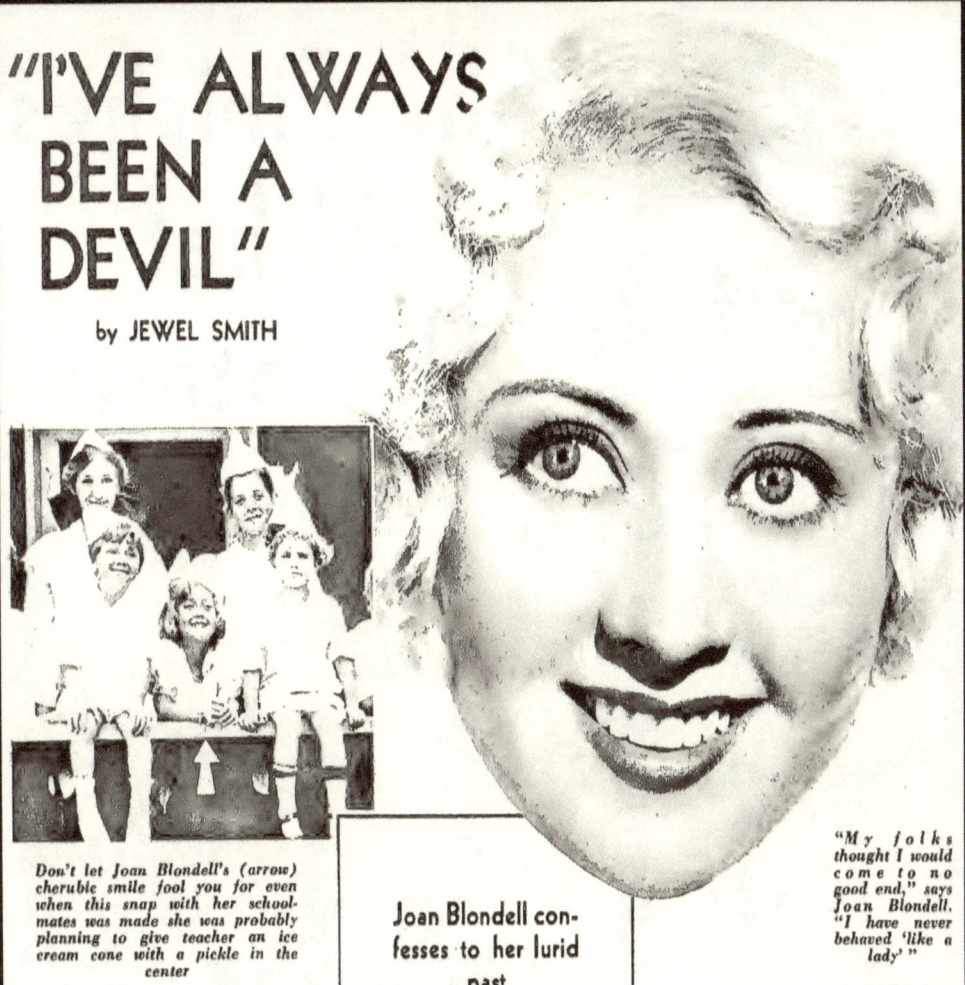

Don't let Joan Blondell's (arrow) cherubic smile fool you for even when this snap with her schoolmates was made she was probably planning to give teacher an ice cream cone with a pickle in the center

Joan Blondell confesses to her lurid past

"My folks thought I would come to no good end," says Joan Blondell. "I have never behaved 'like a lady'"

"I HAVE ALWAYS been a little devil! My folks thought I would come to no good end. I have never behaved 'like a lady.'"

Joan Blondell flung a pair of be-slacked legs over the arm of her chair and puffed decorously at a cigarette. In another moment she squashed it out, took a deep breath, and relaxed whole-heartedly into exposing her past—a past as delightful in its narration as it is veracious.

The staid, commonplace things of life have never intrigued or even curiously interested Joan Blondell. Ever since that day she entered a school room for the first time and discovered that a "new girl" caused a great deal of commotion in the best of schools, Joan decided always to "be different."

She started right then by playing with the boys instead of the girls; shooting marbles with the toughest; making eyes at the prissies; and

scorning the effeminacy of hairbows and laces. Fortunately her father's vaudeville engagements prevented her from attending the same school for more than a week. This arrangement set things up just fine for Joan who had a certain "popularity routine" which she practiced on each successive school with the most gratifying results.

"I would pick out the little girl with curly locks," says Joan. "There's one in every school—the big-eyed youngster who admired me the most. I'd take her aside in all confidence and tell her that I was the daughter of Eddie Blondell, the actor—that I was a pretty swell actress myself, to say nothing of my recitation abilities. It wouldn't be long then until the teacher would ask me up in front of the class to recite "just any little thing." My act, of course, was to

feign bashfulness at first and finally to give in, walk up before the class—and stay there reciting from two to three hours. This worked out beautifully, for near the end of the week, when it came time to shine in my studies, I'd be gone to the next city—and another school."

● These early successes, no doubt, whetted Joan's ambitions for a finer technique of 'misbehavior for when she was nine years old, she had become the only girl on a boy's baseball team, and the recognized best pitcher of the school. The enviable position did not last long, however, for Joan was promptly expelled when she was discovered exploring the tombstones in the graveyard across the street instead of going to "the little girl's room" for which she had been excused.

"At fourteen I was still a hellion. I remember one day try-outs were being given for a show to be pre-

She Finishes What She Starts

How Joan Blondell battled pain and defied
death to complete her latest picture

by MARY NYE

Scene in Joan Blondell's living room when the studio came to her, and she played her part in the last scenes of I've Got Your Number *while still so weak from an appendicitis operation that she had to be carried downstairs*

How WOULD YOU LIKE to go to work on a stretcher? It would take pluck! But, in a manner of speaking, Joan Blondell did just that not long ago. Convalescing from an appendicitis operation, she couldn't go to the studio, so the studio came to her. Or, rather, cameras and equipment came as far as the living room of her lovely home on Lookout mountain. Joan did the rest—even though she was so weak she had to be carried downstairs. Seeing the picture you would never guess that the vivacious girl was concealing weariness and pain beneath her smile. Joan is like that!

Joan let her condition get beyond the danger point in the hope of finishing her part in the picture, *I've Got Your Number*.

Suddenly, a week before production on the picture ended, Joan was stricken with a severe attack of appendicitis. Other slight attacks she had been able to laugh off. This time, though, it was no joke. However, Joan refused to obey orders she go to the hospital. For two days George Barnes, her husband, was numb with anxiety as he watched her move about the set and knew her light manner concealed agonizing pain. But neither his pleadings nor the remonstrances of doctors could persuade Joan to give up.

"I can't quit until my shots are finished," she argued. "I can't leave the picture up in the air."

Good sport! A trouper at heart, she thought of her co-workers and her studio first.

That ended the controversy as far as Joan was concerned. Between shots she rested on a couch with ice packs on her side and gulped down aspirin every hour.

At the end of the second day George looked at her discerningly. "You're through," he announced with jaws set.

"No," she said with trembling lips. "There are still a few shots tomorrow morning."

Get ready for those days in the summer sun by giving your hands and feet the proper attention

Hand and

Footnotes

Pink or flaming scarlet tips on your fingers and toes are just the start of hand and foot beauty, if you want to look as lovely on the beach as does Joan Blondell. Her next film has the challenging title *Good Girls Go to Paris*

By ANN VERNON

Just because your hands and feet are so useful is no reason they shouldn't be beautiful. Don't be the kind of girl who always has her fingers and toes tucked away out of sight. You can't hide them, anyway, if you're young and active. If you swim or dance, or if you're planning to wander through either of the World's Fairs, if you play games outdoors, then you might as well start grooming your toes, as well as your fingers. Beach clogs, street shoes, evening slippers are more cut out than ever. And hands aren't being mittened.

The rules for hand and foot beauty are almost identical. About the only difference is that toe nails should be filed straight across to prevent ingrown nails. Both should be scrubbed twice daily, with soap and water and a brush to keep them clean, to remove bits of dead skin. Both should be decuticled at least once a week with an oily cuticle remover, worked gently around the nails with a covered orange-wood

Any beauty problems today? Our beauty editor will gladly help you solve them. Write to Ann Vernon, HOLLYWOOD Magazine, 1501 Broadway, New York City, enclosing a stamped, self-addressed envelope (U. S. postage) for her reply. No other charge.

stick. Both should be tinted with the same pretty shade of polish.

The feet and legs look better for a little lubrication with hand lotion because of the cobwebby hose we wear and the open-work shoes. Don't think, just because summer is here, that you can put away your bottle of hand lotion with your fur bonnet. Use it generously and frequently to keep your extremities as soft and smooth as your face. Although the popularity of "Little Girl" fashions seems to indicate that we'll all be pink and white and fragile looking this summer, anyone who understands the American Girl's enthusiasm for outdoor sports will realize that she isn't going to forego them, just to stay lighter in skin tone. . . . The shade of your skin will largely determine what color nail polish you'll wear. You'll choose one of the new cameo-pink shades if you elect to remain on the pale side by protecting yourself with anti-suntan creams, or by sitting in the shade. And you'll choose one of the

warm brownish-red or russet shades if you deliberately court the sun. You'll find that a coat of base under your polish on fingernails and toenails will make it stand up better under the wear and tear of summer activity.

⬛ Even the most normal feet—with all fifty-two bones perfect and with nary a corn or callous—often give their owners plenty of discomfort in warm weather. And where there is discomfort, there is a strained facial expression that is fatal to beauty. You can keep your feet in the pink during hot weather by taking care in the selection of your shoes. Change them more frequently than you would in the winter. See to it that they are just loose enough and light enough to prevent pressure. If you have a plump, heavy foot, don't wear heel-less pumps. Wear a light, perforated tie-shoe that gives you enough support. If your feet are thin, beware of built-up shoes that grip the instep too tightly and stop the circulation. Wear lightweight or mesh hose for extra coolness and ventilation, and treat your feet to alternate hot and cold baths night and morning. After each one, massage a cooling powder or lotion all over the feet, between the toes. And keep your feet up whenever you can. That rests them, reduces swelling and that burning sensation.

If you have corns or callouses, yet like to spend a lot of time barefoot at the beach, here's the solution. . . . Some new pads, flesh colored and dainty looking, that cover those angry looking spots neatly and inconspicuously. There are medicated disks that can be inserted beneath the pad to help banish the blemish. The soft pads come in mighty handy without the disks for protecting irritated areas against a too-tight shoe. They're inexpensive and come in several shapes.

When I advised you to be lavish with powder on your tootsies, I had one particular all-purpose powder in mind. It's soft, silky and white and is an excellent odor corrective. Sprinkling it in your shoes and hose, as well as on your feet will keep them fresh and odorless for hours. It absorbs perspiration without clogging the pores, and this makes your feet feel dry and comfy in the muggiest weather. And use it for a soothing all-over body rub after your bath, or when your skin is irritated from sunburn and windburn. It costs only a dime in spite of its super-super quality.

A nail polish house has brought out a scrumptious nail shampoo that is grand for removing dirt and stubborn stains from fingers—or toes. It's a milky white lotion that lathers wildly when you massage with the tricky pink nail scrub. A perfect method for getting your nails spotless without digging dangerously at the cuticle. While the shampoo doesn't dissolve cuticle, it removes dead pieces, and softens and lubricates the cuticle so it can be pushed back in a jiffy. The price of this wonder-worker is 35 cents. The large 60 cent size includes an applicator and the pink rubber nail polish. Want the name?

⬛ With dresses getting shorter by the hour, and playsuits as brief as ever, you must be extra-cautious about keeping your legs smooth and hairless. I can recommend two grand hair removers, one a wax epilator ($1) the other a depilatory cream (50 cents) that do a splendid job of deforesting. The cream is a little quicker, but the wax has longer-lasting effects. Alternating them at least once a week will keep your legs looking as glamorous as a movie star's. . . .

She Finishes What She Starts

George didn't argue, but he quickly bundled her into a car and took her straight to her doctor's office for the second blood count that day.

Both George and Joan had their way. The remaining shots were taken, but not for eleven days because the doctor's first words when he saw the result of the blood count were, "No more stalling. An operation has to be soon."

"Yes," Joan agreed. "I was just telling George there is only a shot or two tomorrow."

"The only shot you'll have is an anaesthetic within the hour," her doctor commanded. To George he remarked, "Drive straight to the hospital."

That was that. In spite of vain sputterings, Joan was operated upon as her doctor had said, "within the hour."

A WEEK LATER when I walked into Joan's hospital room I found her sitting up in bed. Casually I mentioned the unfinished picture.

"It wasn't so serious, not getting to make those last shots," Joan confessed. "I can still do them because it just happens the script calls for me to be in bed."

So that was what had been in Joan's mind as she had lain there passively! Sure enough, the next thing I heard Joan was home. At the studio they had finished everyone else's part except Joan's final scene with Pat O'Brien and that was going to be taken in Joan's own home the next day.

Early that morning the neighbors looked out to see Warner's big trucks loaded with powerful lamps, cameras and set equipment backing up and unloading at the Barnes'. Forty-one men came along to shoot that little scene. Inside Joan's nurse was fluttering around.

"She shouldn't do it," she fumed. "But she's bound and determined. Thwarting her is worse than to let her do it."

Joan was sitting up in bed all dressed up in the studio lace-trimmed gown and a frilly negligee, her eyes dancing with excitement. "I'm ready, George. Come on and take me down," she called.

Downstairs Joan's living room had been transformed into a studio set. A long silk throw was hung from the balcony railing as a background for the bed.

IT WAS ELEVEN days since Joan had seen all the stage force assembled but here they were, overflowing the living-room, up the steps into the dining-room. She was thrilled and excited at seeing them all again. "Hello, everybody," she called gayly from the second landing.

There was an effort at a genial response which faded into a hushed silence as Joan was gently laid on the bed. It was a strange, tense moment. Later one of the technicians said, "It suddenly hit us all when we saw Miss Blondell being carried down those steps, still looking plenty sick, that here we were, all hale and hearty, so engrossed in studio business that unwittingly we were using up the only bit of reserve strength the girl had, just to be able to finish a job."

Of course the truth was the studio had not suggested such a thing. It was Joan's own plan.

This pluck of Joan's in determining to finish her picture at any cost to herself will make *I've Got Your Number*, when I see it on the screen, a little different picture to me than it would have been.

MY PAL *Glenda*
by Joan Blondell

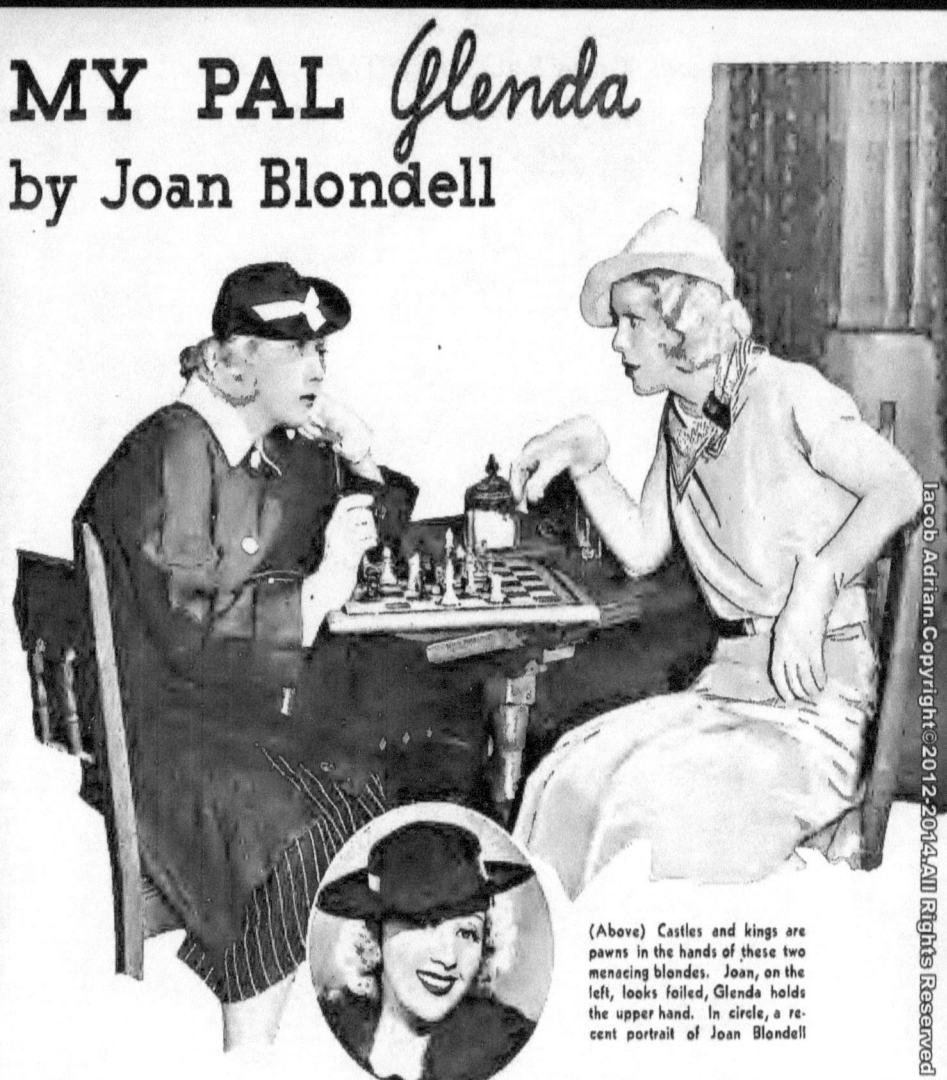

(Above) Castles and kings are pawns in the hands of these two menacing blondes. Joan, on the left, looks foiled, Glenda holds the upper hand. In circle, a recent portrait of Joan Blondell

No ONE WOULD be able to enjoy a case of the blues with Glenda around. She would start to console you and before you realized it you'd be laughing and it wouldn't be because Glenda had made an effort to amuse you. She just can't help but be funny.

That is one of the many reasons why she is so delightful to work with. Never a dull moment. She is a comedienne by accident rather than design for no matter how serious she takes her work before the camera, the finished product plays havoc with your funny bone.

Working with Glenda is splendid for me but hardly fair to her. You see, I am starred which means that I have the love interest and also share the comedy with her. In most pictures where two girls work together, one plays the sweet ingénue and the other the comédienne or villainess and in that way one does not take from the other.

Glenda and I do the same type of rôle which means that she must share her honors with me. With most girls such a state of affairs just wouldn't work, they would want their honors all to themselves. Not so with Glenda. In fact, she goes to the other extreme to build me up in my comedy.

● GLENDA IS, at all times, very natural. She isn't one bit camera-conscious. Doesn't know a good angle from a bad one and works just as hard with her back to the camera as facing it. Her movements are always quick, her speech spontaneous. When she goes into a scene she never follows the script to the sacrifice of her natural-ness. She acts just as she would if the same situation arose in her every-day-life. In other words, she suits the part to her personality instead of trying to suit her personality to the script.

She handles dialogue the same way and never tries to twist her tongue around expressions foreign to her own way of speaking. Before we go into a scene, we go over our lines together and revise them, without changing their meaning, until they fit our mouths.

Stars
Own
Stories

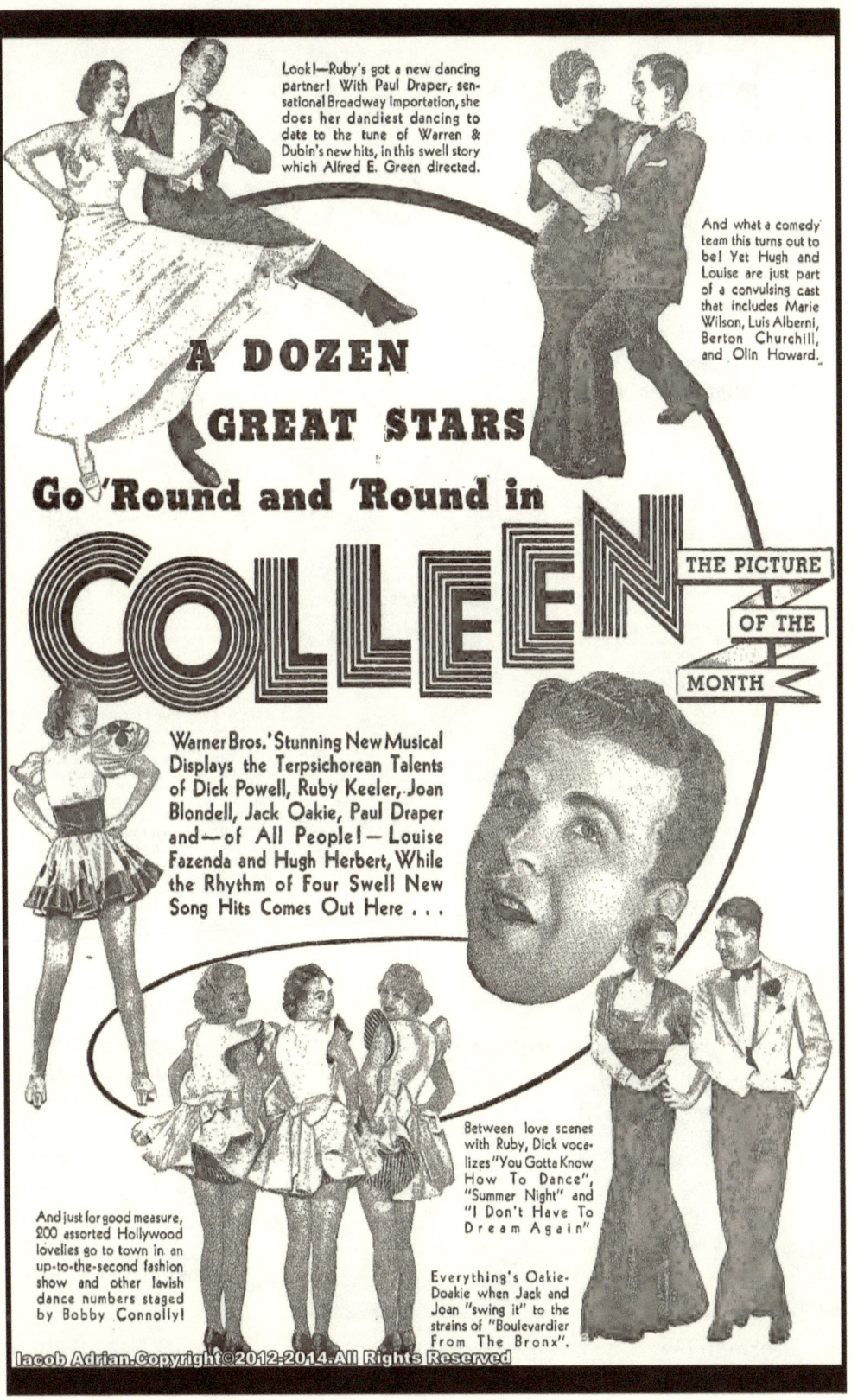

Look!—Ruby's got a new dancing partner! With Paul Draper, sensational Broadway importation, she does her dandiest dancing to date to the tune of Warren & Dubin's new hits, in this swell story which Alfred E. Green directed.

And what a comedy team this turns out to be! Yet Hugh and Louise are just part of a convulsing cast that includes Marie Wilson, Luis Alberni, Berton Churchill, and Olin Howard.

A DOZEN GREAT STARS
Go 'Round and 'Round in
COLLEEN

THE PICTURE
OF THE
MONTH

Warner Bros.' Stunning New Musical Displays the Terpsichorean Talents of Dick Powell, Ruby Keeler, Joan Blondell, Jack Oakie, Paul Draper and—of All People!—Louise Fazenda and Hugh Herbert, While the Rhythm of Four Swell New Song Hits Comes Out Here . . .

And just for good measure, 200 assorted Hollywood lovelies go to town in an up-to-the-second fashion show and other lavish dance numbers staged by Bobby Connolly!

Between love scenes with Ruby, Dick vocalizes "You Gotta Know How To Dance", "Summer Night" and "I Don't Have To Dream Again"

Everything's Oakie-Doakie when Jack and Joan "swing it" to the strains of "Boulevardier From The Bronx".

MY BIG SIS
Joan Blondell

by
GLORIA
BLONDELL

They could put on a swell sister act if Gloria didn't prefer the stage to the screen

Star's Own Story

Gloria Blondell, on the left, bears a striking resemblance to Joan. You'll enjoy reading about their childhood together

JOAN IS MY big sis, and I think irrespective of her real relationship to me, she is one of the grandest girls in the world.

When we have been up against starvation and almost insurmountable obstacles it was Joan who got busy and pulled us out of it every time. When success came to her she swung ahead into prosperity and popularity and took us right along with her every step of the way.

To me, she is the most unselfish, gallant and energetic bundle of pep and sweetness you can imagine—and I mean that with my whole heart and soul. In the many years of our close relationship I've never seen her shirk a duty, nor a responsibility. She has always tried to shield me from the rough bumps she has had—and boy, has she had them!

Everyone knows the story of how she jumped out of an automobile going 40 miles an hour because the man she had trusted turned out to be "fresh." She'd take chances with the unknown any day rather than give up one of her ideals—and Joan has so many ideals.

Once she was so ill in Peking, China, she had to go to the hospital and let the troupe she was traveling with go on without her.

Three weeks later she recovered sufficiently to leave the hospital. She put her remaining money into a trunk and sent it to the station. When she arrived at the station she found it in flames and she had to stand there and watch her money, clothes and all her earthly possessions go up in smoke.

She was weak and ill but she went to work washing dishes for coolies until she earned her steamer fare back to join her troupe again. She never asked them for help. She said they were having all they could do to take care of themselves—that's Joan for you!

● THAT SIS OF mine has seen life, faced death, and been stranded in so many places and fought to get us all out of tight jams so often that nothing can daunt her now—not even Hollywood. She will never lose her clear-headed sense of values.

She has built about herself a perfect defense against every form of superficiality and pose.

AN ICY DIP « « « « « GLORIA SHEA

Let's get it over with . . .

Whoopee! It's cold as ice . . .

Aw, come on in—the water's swell!

My Big Sis

She can spot the sincere and down-to-earth thing in a second. She has no patience with pretense of any kind. I wish everyone who loves her on the screen could know her in person. That's the sort of good guy she is. Better to know than just to see.

She has always made me her responsibility. She has watched over me, talked to me, guided and protected me from everything that might have been tough. When I graduated from High School she had a long talk with me and wanted me to decide just what I wanted to do. I have a leaning toward art and she was willing to send me to Europe to study if that is what I wished. But after all, Joan and I were brought up in a trouper's trunk and the stage is our first love. I chose the stage and screen as a matter of course. She immediately arranged a screen test for me at Warner Brothers.

She schooled me in just what my test would be like and if I hadn't passed it certainly wouldn't have been her fault. It was all right I guess for they did offer me a contract.

But then we talked it over, as we do everything that concerns either one of us, and Joan advised me not to go direct on the screen. She said she thought I would be so much better with some stage experience first. I agreed with her as I always do, for her wisdom is so clear, direct and sensible.

● WHEN JOAN HAS something on her mind—she never rests until it is off her mind and settled. So a few days later she brought me the opportunity to play the leading role in *She Loves Me Not* on the stage in Ann Arbor, Michigan. She placed this opportunity right in my lap—like a mother bird brings it's fledglings food.

So you see I cannot help but be grateful to Joan for my life has been made so easy all due to her efforts. I truly believe that it is largely due to Joan that our family has never been separated for any length of time. We cling to her and depend on her love and help in everything that comes into our lives. Perhaps we shouldn't but I think Joan would miss it if we didn't.

It wasn't until Joan got a job with George Kelly in "Maggie the Magnificent" that things began looking up for the Blondell brood. It was in George Kelly's office that Joan first met Jimmie Cagney. He was also looking for a job in this show. She told us when she came home she had met a red-headed, freckle-faced "mug" at George Kelly's and that he was rather a dear, down on his luck, and with a grand sense of humor.

● FUNNY THAT LATER she should play opposite him in *Penny Arcade* and that they should both be brought to Hollywood to do this play on the screen, and that their careers should have traveled the same road in Hollywood. Both are stars today, of course, and the best of pals. They often laugh about that first visit they had in George Kelly's office, both broke and looking for a job.

Joan and I have shared every little joy and sorrow. We've shared clothes and all our thoughts. We study everything together. She mothers the whole Blondell bunch, and we all, even mother and father, take our troubles to Joan to solve. She's so darn good at that sort of thing!

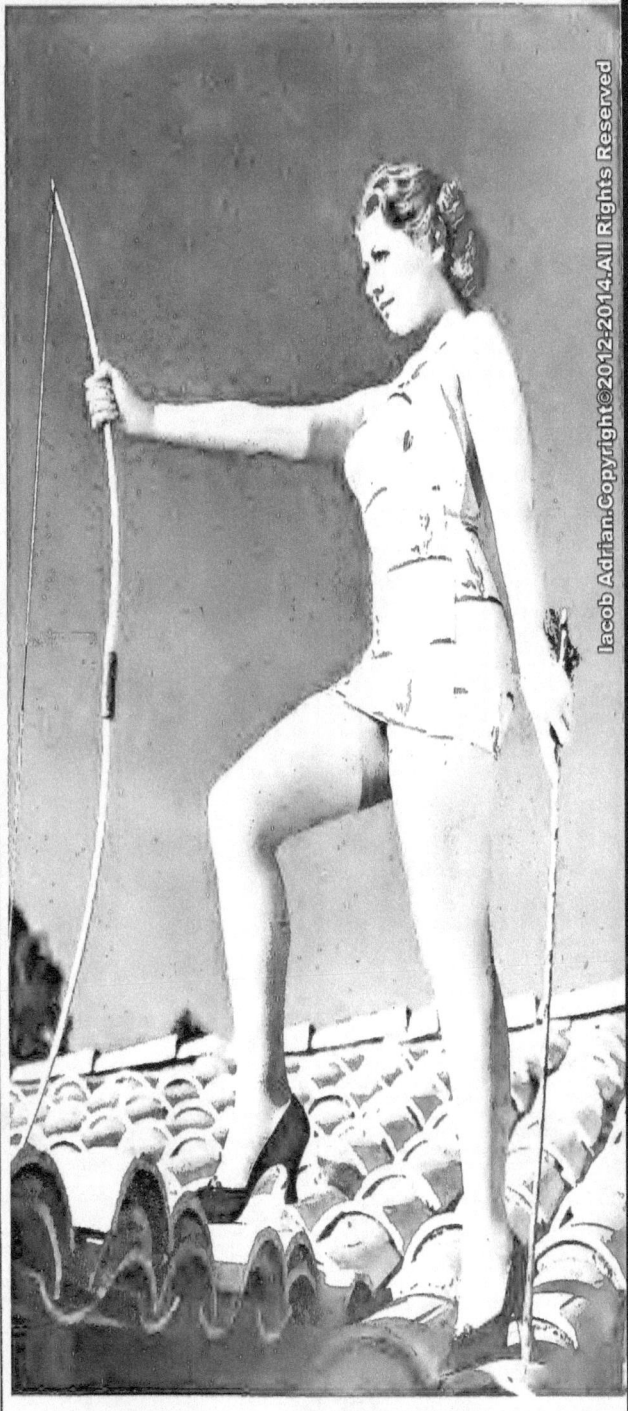

It's springtime in California, and playtime for lovely Joan Blondell. Her romance with Dick Powell is one all Hollywood looks on with approval

haps because I was a small-town boy I'd learned to believe that black is black and white is white and that men who accept things from women become a little less than men. I—well, naturally I didn't go. And the lady is no longer numbered among my hostesses.

"There was the fairly recent case of the young blonde beauty who moved into the house two or three doors from mine. I first noticed her walking her dog back and forth in front of my place. Not obviously at all. After a few days we reached the point of saying good morning or good afternoon when we met. She looked well-bred and intelligent and extremely attractive. I began to think to myself 'Ah, there . . .' and to feel self-congratulatory because I was free, white and over twenty. I also began to figure that perhaps you should love your neighbor as yourself or something—and that there was no special reason why the young, blonde and undoubtedly beautiful person should be kept standing *outside* my gate as we passed the time of day.

"In fact I had just got to the point of figuring how best to invite her to lunch or dine with me when a friend of mine called me on the phone and—*warned me.*

"He first asked whether a young girl answering to my young neighbor's description had moved into the house near me. When I told him that she had indeed he advised me that this was the young lady who had recently 'shaken down' another actor for a considerable sum of money. He warned me that all she needed was to step foot over my threshold and the 'fun' would begin. She would, I was told, employ any means which presented themselves. Even marriage would not be amiss. I was to beware. I did—I bewared beautifully and completely. I was deaf, dumb and blind when next we met. I did a vanishing act. And in an unflatteringly short while the house was vacant again.

● "I MISSED THAT TEMPTATION by the skin of my teeth. And no more. I was all set to succumb. And *very* unflattering it was, too, to realize that all those beguiling smiles and warm, friendly words and pleasant interchanges over the garden wall had been, not for my manly charms, but for my presumed bank account!

"I've also discovered this," said young Mr. Powell, gray eyes level and very serious as they are when talking about serious matters, "I've discovered that it is not among our fellow stars that we actor chaps find temptation. The stars we work with are far too busy with their own work, their own careers, their own problems to engage in any trivial temptings. The temptations of the actors come from the ranks of the extras, bit players but mostly from girls and women on the 'outside' . . . girls and women some of them pathological, some of them hysterical, some of them merely and coldly ambitious who figure that they may advantage themselves in one way or another if they can attract an actor. . . .

"It is a great temptation not to become suspicious of everyone, all the time. It's a bad condition because it makes me, it makes us all wary and suspicious, fearful of proffered friendships, cool and cautious with charmers who might well be as charming to know as they are delectable to look on. I know darned well that I lose many friendships, forego many pleasant hours because I am *afraid.* . . . We have to keep our

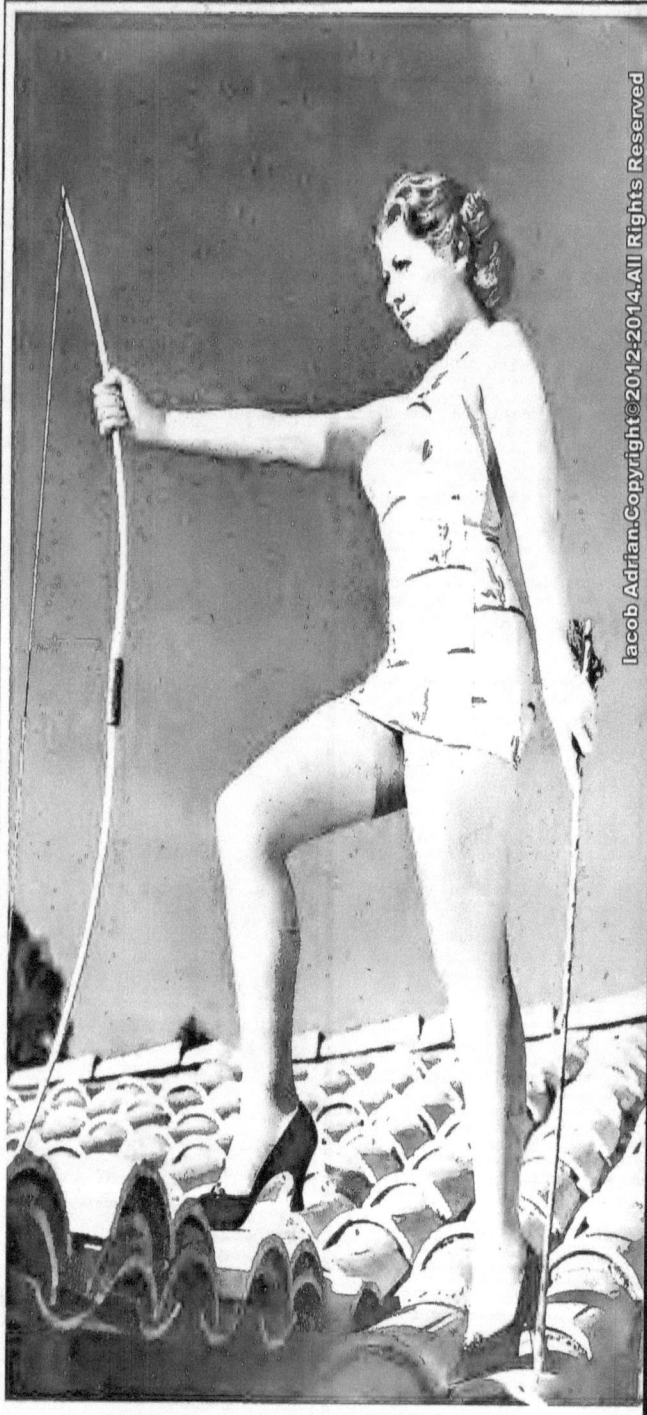

It's springtime in California, and playtime for lovely Joan Blondell. Her romance with Dick Powell is one all Hollywood looks on with approval

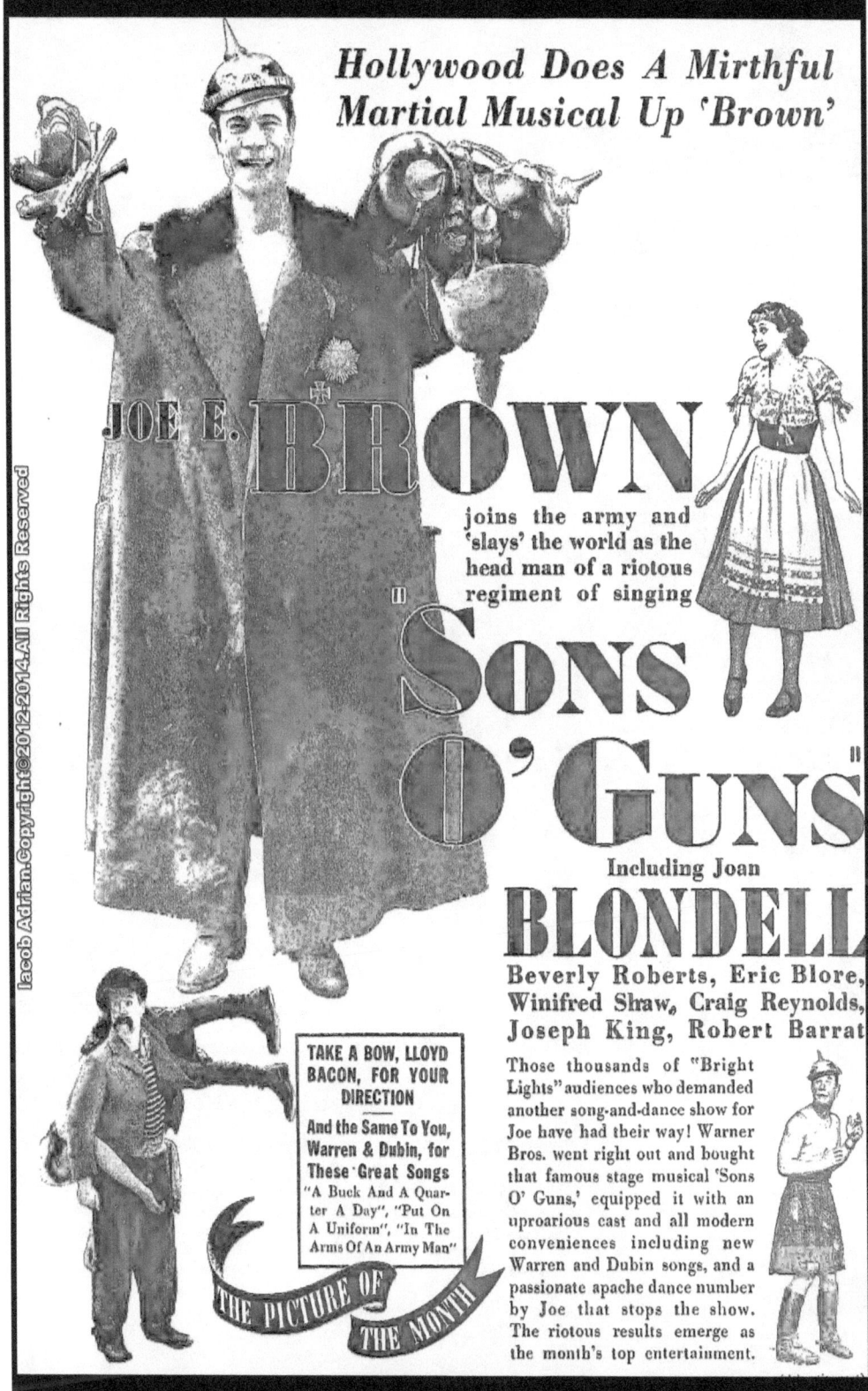

Hollywood Does A Mirthful Martial Musical Up 'Brown'

JOE E. BROWN

joins the army and 'slays' the world as the head man of a riotous regiment of singing

"SONS O' GUNS"

Including Joan

BLONDELL

Beverly Roberts, Eric Blore, Winifred Shaw, Craig Reynolds, Joseph King, Robert Barrat

TAKE A BOW, LLOYD BACON, FOR YOUR DIRECTION

And the Same To You, Warren & Dubin, for These Great Songs "A Buck And A Quarter A Day", "Put On A Uniform", "In The Arms Of An Army Man"

Those thousands of "Bright Lights" audiences who demanded another song-and-dance show for Joe have had their way! Warner Bros. went right out and bought that famous stage musical 'Sons O' Guns,' equipped it with an uproarious cast and all modern conveniences including new Warren and Dubin songs, and a passionate apache dance number by Joe that stops the show. The riotous results emerge as the month's top entertainment.

THE PICTURE OF THE MONTH

Come On, Everyone
THE PARTY'S
ON AGAIN!

Glenda coos the new Gold Digger's lullaby—"With Plenty of Money and You"— to those dashing heartbreakers and champion funmakers—Victor Moore and Osgood Perkins!

Take a bow, Lee Dixon, for stealing the show from Hollywood's fanciest steppers with the dazzling dance stuff that made you the overnight sensation of Broadway's hot spots!

Busby Berkeley achieves a new pinnacle in rhythm as he introduces his 170 newest beauty discoveries in that stunning dame and ditty number—"All's Fair in Love and War"

RING out the old...SWING in the new! 1937 comes to town in a blaze of syncopated merriment as Warner Bros. go to town with a superlative new edition of "Gold Diggers". Mirth and maids and melody...lyrics and laughs and lovely ladies...packed with lavish profusion into a glorious show set to the split-second tempo of Warner Bros. musicals!

DICK POWELL

JOAN BLONDELL

in

"GOLD DIGGERS OF 1937"

VICTOR MOORE · GLENDA FARRELL · LEE DIXON · OSGOOD PERKINS · ROSALIND MARQUIS · Directed by LLOYD BACON...A First National Picture with songs by Harry Warren and Al Dubin, Harold Arlen and E. Y. Yarburg

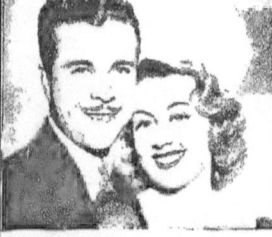

And "Speaking of the Weather", it's fair and warmer for everyone concerned when Dick lets himself go with that grand new love song the tunesmiths made to order for his lady love!

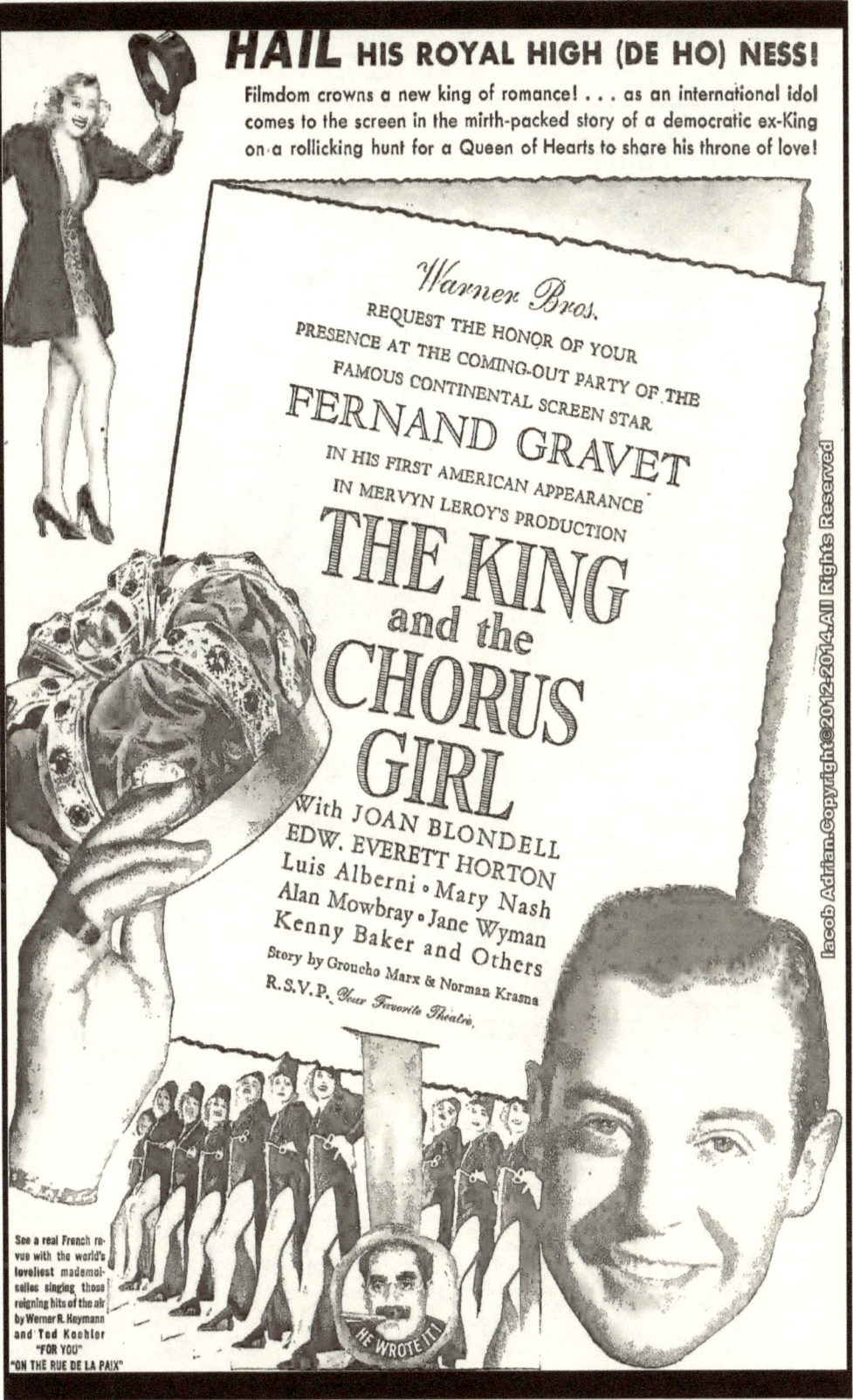

HAIL HIS ROYAL HIGH (DE HO) NESS!

Filmdom crowns a new king of romance! . . . as an international idol comes to the screen in the mirth-packed story of a democratic ex-King on a rollicking hunt for a Queen of Hearts to share his throne of love!

Warner Bros.
REQUEST THE HONOR OF YOUR
PRESENCE AT THE COMING-OUT PARTY OF THE
FAMOUS CONTINENTAL SCREEN STAR
FERNAND GRAVET
IN HIS FIRST AMERICAN APPEARANCE
IN MERVYN LEROY'S PRODUCTION

THE KING
and the
CHORUS
GIRL

With JOAN BLONDELL
EDW. EVERETT HORTON
Luis Alberni • Mary Nash
Alan Mowbray • Jane Wyman
Kenny Baker and Others
Story by Groucho Marx & Norman Krasna
R.S.V.P. *Your Favorite Theatre.*

HE WROTE IT!

See a real French revue with the world's loveliest mademoiselles singing those reigning hits of the air by Werner R. Heymann and Ted Koehler "FOR YOU" "ON THE RUE DE LA PAIX"

Meet Filmland's Newest *King!*

UNLESS WE MISS our guess, Hollywood will have to include among its "certain people of screen importance" one Fernand Mertens Gravet, the handsome continental film star imported last October by Director Mervyn LeRoy for the lead in *The King and the Chorus Girl* recently completed at the Warner Bros. studios.

No little credit attaches to LeRoy for his capture of this idol of the European stage and screen. For five years, and in as many different languages, Gravet had been voicing an emphatic "no" to representatives from Paramount, Universal, Radio, and Metro-Goldwyn-Mayer who implored him to sign his name to a Hollywood contract.

Director LeRoy, noted for the great speed he exercises in taking old man Time by the forelock, saw Gravet in a French picture last summer while in London and decided to skip over to Paris to talk contract with the European star. Arriving in Paris, LeRoy learned that Gravet was entertaining friends at a private party. The American producer, with a tight grip on the aforesaid forelock, managed to receive an invitation to the same party and within two hours a movie contract was signed, sealed and delivered—but only after LeRoy not only had promised, but guaranteed the following provisos: Gravet was to star in American pictures; each of these pictures was to be produced and personally directed by LeRoy; and, finally, once Gravet was in Hollywood, he would immediately begin his first picture.

Gravet, who is as canny as a Scot and knows how to strike a bargain, laughs when he reviews the speed and efficiency that greeted his arrival in Hollywood. Director LeRoy more than kept his guarantees.

"Mr. LeRoy more than met my demands," he explained. "He made a test of me the first day on the Warner lot. The following day I was having wardrobe fittings. The third day was devoted to dialogue and photographic tests. The following day I met Joan Blondell who was to co-star with me. And on the fifth day I began the first scene for *The King and the Chorus Girl.* I thought I knew something about picture making, having worked in 30 foreign films, but I'm still gasping in amazement over the American method, which, I hasten to add, is far superior to Europe. But not only that," Gravet went on, "it was a delightful surprise to find everyone on the set—from the director down to the grips—so eager to make *The King and the Chorus Girl* a success. Warner Bros. studios was really home to me after that first day."

A warm, friendly, affable chap, this Fernand Gravet promises to take the cinema world by storm when his first picture is released. He looks, talks, and acts more American than European and is a "regular guy" if you care to take the word of the hard-boiled props, grips, electricians and extras on the Warner lot.

Here you see a romance team that promises to find a place at or near the top of your film-favorite list—Fernand Gravet and Joan Blondell in *The King and the Chorus Girl*

Gravet was born in Brussels, Belgium, on Christmas Day, 1908. He was educated at St. Paul's School at Hammersmith, England, as was his father. From 1917 to 1919 he was in the British navy as a Marine Cadet. After the Armistice he returned to Brussels and took over from his father, now ill, most of the managerial work connected with the Galleries St. Hubert. About this time Gravet's mother was winning acclaim as a character actress and a few months later young Gravet joined her stock company in a tour that embraced all the European countries, not to mention Turkey, Egypt and South America. In addition to being baggage master and transportation chief he found time to appear on the stage in small bits. Before long the bits grew into real parts and, although he didn't know it then, he was headed for America.

A Ripley touch is added to Gravet's life at this point. His father began his stage career with Doris Keane in *Romance.* Gravet's real stage debut was also in *Romance* with Mlle. Soria at the Athene theatre in Paris in 1922. From 1922 to 1930 he appeared in more than 30 plays in the French capital.

His stage career was cut short in 1924 when he was called to the Belgian colors to serve his required two years in the army. One year of this service was spent in the cavalry and the second in the balloon corps acting as an observer for artillery maneuvers. Back to Paris, then, to resume his stage career, he met and married the Parisian stage star, Jane Renourdt, with whom he co-starred for the following three years.

Gravet's introduction to pictures was at the UFA studios in Berlin. Eager to know more about this new field of entertainment he got a job as cameraman after the picture was finished and followed that up

HAIL! *the conquering hero comes!*

Hollywood hails Atterbury Dodd...the timid soul who took the studios to town! Are there laughs? Is there romance? Are there thrills? Clarence Buddington Kelland, the Saturday Evening Post author who gave you "Mr. Deeds" and "Catspaw", never wrote a funnier adventure...and with this star-studded cast tossing the excitement together...Wow!

WALTER WANGER
presents

LESLIE · JOAN
HOWARD · BLONDELL
"Stand-in"

with HUMPHREY BOGART

ALAN MOWBRAY · MARLA SHELTON
C. HENRY GORDON · JACK CARSON
Directed by TAY GARNETT
Screenplay by GENE TOWNE and GRAHAM BAKER
Released thru United Artists

portraits

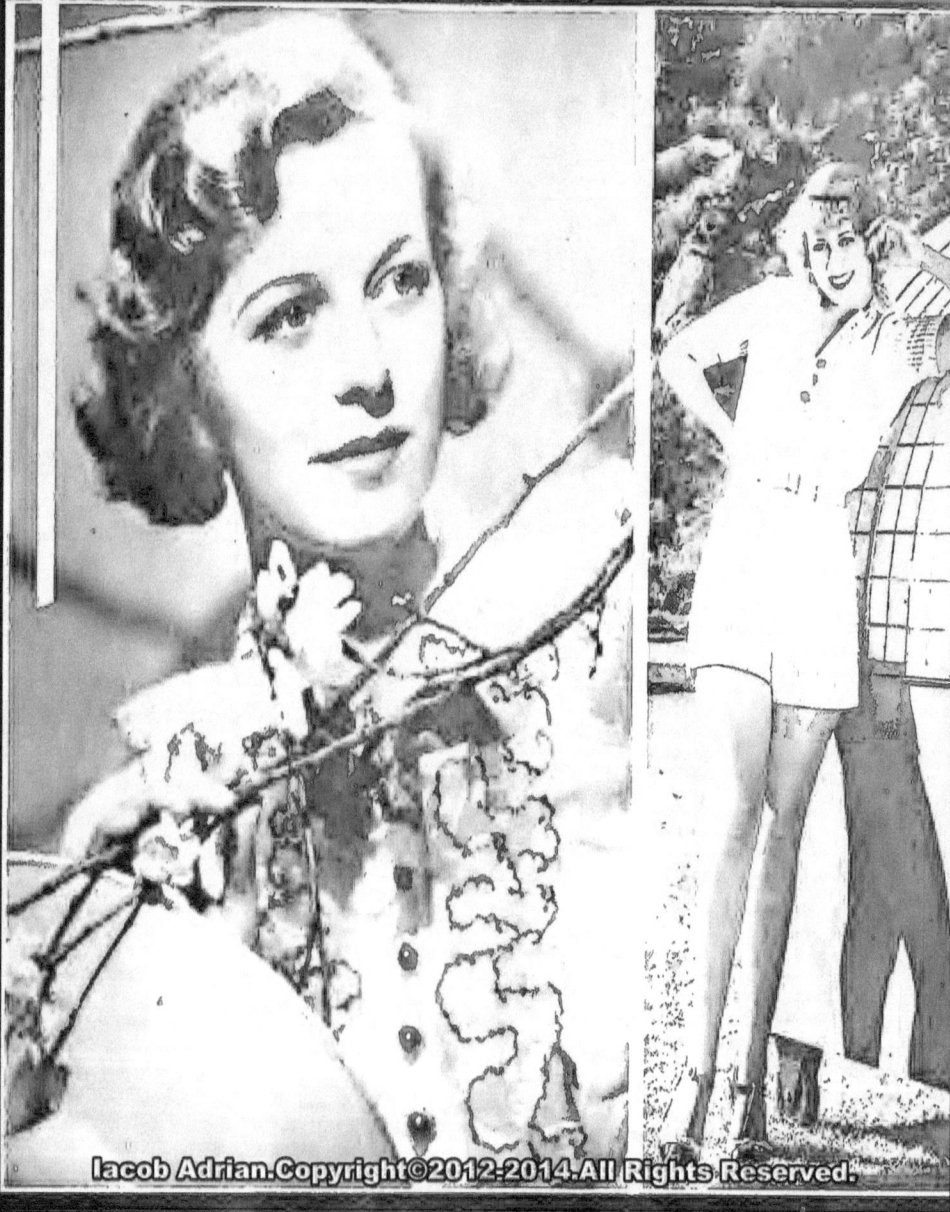

MARGARET SULLAVAN

—Jack Freulich

• Like a token of spring, Margaret's personality brings a refreshing new element to the Hollywood scene. It is expected she will repeat her success of *Only Yesterday* in *Elizabeth and Mary* and *Little Man What Now?* which will soon be ready for showing

JOAN BLONDELL

—Scotty Welbourne

• After a short convalescence on Mohave Desert following her recent appendectomy, Joan faced the cameras for *Without Honor*

ONLY 5 CENT MOVIE MAGAZINE IN THE WORLD

Hollywood

SCREEN LIFE

A FAWCETT PUBLICATION
HOLLYWOOD
5¢

AUGUST

NSC

MOVING DAY WITH
THE DICK POWELLS
SEE PAGE 24

BEHIND SCENES ON "THE WIZARD OF OZ" SET

Moving Day

Especially posed for HOLLYWOOD

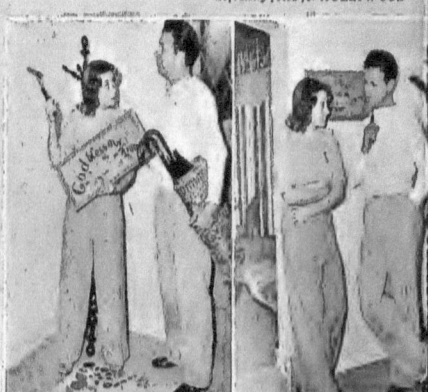

Should be easy to find a place for the sampler

It looks nice *anywhere*, but is this just right?

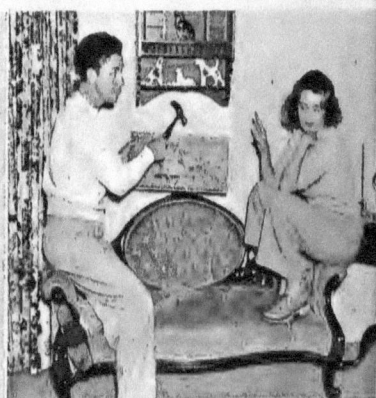

Dick fights on, but now he is sitting down to his work. Joan's mood is unmistakably critical

Above you see home-maker Dick Powell and his little helpmate, Joan Blondell, arriving laden with the last load of family treasures. What happened after they stepped inside the house is a tale you shouldn't miss

■ It's all mixed up, sort of, the way Joan Blondell and Dick Powell happened to move into this new house of theirs, and I got the black eye. Dick had built himself a swell bachelor's house in the swank Toluca Lake section of the valley. When he and Joan got married they traded it for a house in Beverly Hills because somehow a bride and a bachelor's house aren't quite compatible, if you know what I mean. Well, after a while they sold the Bev Hills place because there was no room for the kids, 4-

year-old Normie, and Little Ellen, who is just 8 months, to play in the back yard. And the law says you can't put a fence around your front yard because it destroys the symphony of the landscape or something. Fine thing!

While they were making up their minds exactly what kind of a house they wanted, and were trying to find it (which is something else again and don't let the real estate agents tell you different) they rented a house out in Bel Air which is where some of our bigger stars live, and where you can build a 50-foot wall around your place if you have a mind to. They were there just six months when Dick saw The Bargain and bought it cash on the line.

With the Powells

By KAY PROCTOR

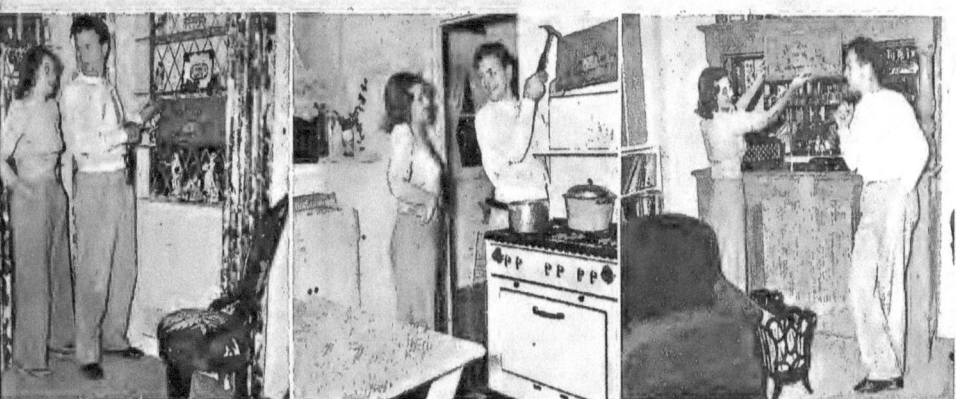

Dick gets whimsical and it goes over quite big

Dick is still gay, Joan is showing the strain

Joan makes a quick rally, Dick looks somewhat pained

The day wears away, but the Powells won't admit defeat

"Want to hang it on the floor?" Dick is desperate

"Let's just build a wing for it," and so far into the night

The Bargain may be a *little* smaller than Grand Central station in New York, but I wouldn't give you a dime for the difference. It nestles cosily in Coldwater Canyon and the asking price was $140,000. (If you want to take the trouble to look up the escrow records you'll find Dick did *not* pay that much for it because he is dumb like a fox when it comes to business). But they didn't move there after all. It had plenty of yard for the kids and was a gorgeous place, but, as Joan said, it would be unthinkable to come down to breakfast in anything but a court train and the regulation three feathers, and that was a bit too much trouble these days. Informal, that's Joan. Besides, they can't keep chickens. Dick is allergic to them.

So they kept on looking and looking for a house that would be just right.

If Joan hadn't made a mistake, they wouldn't be where they are today. She was driving into town in her car and Dick was following in his. Somehow she made a right turn at the wrong corner and landed at the far end of a dead end street. And there was this house with a big FOR SALE sign stuck up in front. And I'll be darned if it wasn't *exactly* the house they had been looking for!

It's a nice house, not a bit movie-starish, in a good but not fashionable district. It's pure English outside and a little bit of everything inside, as you will see. The wide front lawn is a mess, at present, because the caretaker apparently trusted to

God and the California high fog for water but the landscapers already were there when I was, doctoring up the lovely tall eucalyptus trees and getting things ship-shape again. Fay Wray and John Monk Saunders used to own it, but due to the distinctive Powell-Blondell touches, none of them would ever know the place now, what with Penelope sitting in the entrance hall and Mabel and Joe plumped down on the fireplace. Penelope is a brass umbrella stand and Joe and Mabel are a couple of old-fashioned gaboons Dick hooked from the Waldorf-Astoria bar. Neat, but definitely not gaudy. So much for the house. It is attractive, roomy but not vast, and well endowed with the chief charm of hominess.

Moving Day with the Powells

I would not have got that black eye, I'm convinced, if Joan and Dick hadn't tried to move intact in one day! I'll grant they don't have much time to throw away, what with Joan working her head off in Columbia's *Good Girls Go to Paris* and Dick with his weekly Lifebuoy Soap radio program, but still . . . It wasn't the work, you might say, it was the *confusion*.

Not that I did much back-breaking work, either. As I remember the day, I occupied myself chiefly with playing with Myrtle, finding Oscar, and experimenting with Emily-Lulu at the bar. The latter wasn't half as much fun as it might sound, for Emily-Lulu is a baffling sort of a contraption which probably was the original inspiration for the surrealist school of painting. As nearly as I can describe, it is a castiron coconut with a hole in the top into which a beak-nosed mouse, also castiron, is trying to chase its tail. Well, that's the way *I* saw it, and the bar wasn't open for business. Dick uses Emily-Lulu for a tobacco jar, I found out later. Myrtle is a pint-sized adding machine, and Oscar is an adjustable steel stretcher on which Dick's wool sox are dried.

■ Maybe I forgot to mention that everything around the place has a given name but don't ask me *why*. There's even a shaving mug labeled MOTHER. Things like that make for confusion, you must admit. They even reduced one of the professional movers to tears.

"Put Bessie on top of the oven," Joan directed him. "Horace belongs in the bathroom corner, dump Mrs. Fullerton down the back stairs, and throw The Unwanted Bride under Mr. Powell's bed."

For a moment the gent stared with that frozen kind of a look you get when someone bops you unexpectedly on the head. Then slowly he stroked his perspiring brow.

"Lady," he told her gently, "you don't want a mover, you want a doctor!"

As he explained to his boss later, how was he to know Bessie was a copper tea kettle, Horace was an electric hair dryer, Mrs. Fullerton was a straight-backed chair with a broken leg, and The Unwanted Bride a large colored photograph of Mrs. Powell in her wedding dress which never had been hung because it never matched any room?

■ Another of the workmen, an electrician this time, also had a bad moment or two with Joan.

Joan's back has a tendency to ache whenever she gets overtired, but she has found a few moments of the old knee-chest gives her quick relief. To achieve the knee-chest you get down on your knees on the floor, and place your chest as close as possible but also touching the floor. Anatomically the result is a bit startling, although a sculptor might make something of it.

Joan was tired and her back ached, so she sought some secluded spot in which to practice her gymnastics. There were, however, four telephone men, two furnace men, a plumber, a draperer, the cook, the butler, the maid, the secretary, the chauffeur and the electrician in the house at the moment, and one or more of them in every room. Finally Joan found a spot to herself—a dark cubby hole of a closet at the end of the hallway—and took her stance.

Suddenly the closet door was opened and there stood the electrician gazing down in unconcealed surprise, not untouched with alarm.

"How do you do?" Joan greeted him gravely. "Lovely weather we're having, isn't it?"

It seemed the friendly thing to say, she explained later.

■ Everyone was choosing up sides for an Easter egg hunt when I arrived at the house. I mean it! You see, last Easter Joan had colored some eggs for Normie and hidden them about the Bel Air home. Two never had been found. She knew because she remembered hiding an even dozen. She knew, too, that they *had* to be found because in the last-minute rush she had forgotten to cook them before coloring them, and you know what eggs will do, given sufficient time. She had hoped they would be revealed in the packing process but they hadn't turned up.

I got the south half of the living-room and a dour faced packer named Rudolph. Maybe it was my nose for news, but ten minutes later I found the missing egg, carefully tucked in two apertures at the top of an old-fashioned milk glass lamp. (There were 8 old-fashioned lamps in my half of the room, by the way, and 13 glass dogs in a what-not, 30 pieces of crystalware on a window shelf, 11 steins over the bar, 16 pieces of pewter, 4 dueling pistols, 2 cap guns, and 2 horn powder pouches.)

Rudolph confessed to having packed the lamp and when I chided him on not spotting the eggs he said hell lady, the lamp being what it is, I thought them eggs was part of it!

■ Lunch was a gala interlude with all eighteen of us sitting around on the living-room floor munching nutty hamburgers, which Dick brought in from a nearby hamburger stand, and drinking cokes out of paper cups. To add a homey touch, Joan put a silver candelabra in the middle of the floor and lighted its tall green tapers. Always mother's little hostess, that one! Unfortunately Dick had to make a hasty exit in the middle of the party; he choked on a piece of bun.

He and Joan were wearing slacks and sweat shirts which were pretty well dirtied up by that time, you see, so that when Dick invited a latecomer workman to draw up a chair and join us, there was little to distinguish the hosts from the guests. Grabbing himself a sandwich, the man sat down.

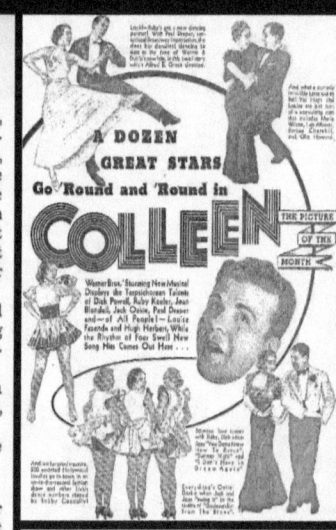
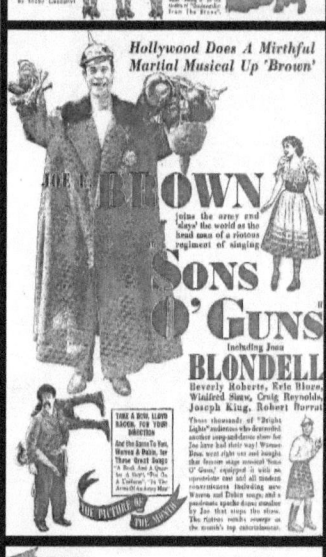

"Jeez, this is gonna be some dump," he said admiringly. "Who's gonna live here?"

"Joan Blondell and Dick Powell," Dick told him.

"Yeah? You mean *together?*" the man clucked in a shocked voice. "The murder them stars try to get away wit!"

■ I was minding my business as nice as you please when I got *my* shock. As I remember I had just finished unwrapping a vicious looking machete (Dick bought this particular Mexican knife at what he thought was a great bargain in Guatemala only to discover *Made in Chicago* stamped on its steel blade when he got home!) when the vision came dashing down the stars in answer to the urgent message that the insurance man was there and wanted to see him immediately on important business.

It was Dick in a pink organdy picture hat with a blue velvet crown and trailing blue streamers!

He and Joan had been unpacking a box of her hats, it seems, when they came across the little pink number which had been her wedding hat. While they wallowed in sentimental memories, Dick unthinkingly had donned the hat and forgotten all about it.

We had finished unpacking Ellen's baby shoes which had been cast in bronze; the lantern from the bar in the old Powell home in Berryville, Arkansas; a blue plush family album with no pictures in it (snoopy me, I looked!); a Tahitian spear rolled up in a home movie screen; Aunt Mamie's green and pink hooked rug; two rapiers; a walnut spinning wheel; a four-pronged hat-rack; a 10-piece "Lazy Susan" silver chafing dish set (Joan's anniversary present to Dick); a model of *Galatea*, his 68-foot yawl; a 1936 Arkansas automobile license plate No. 1; an issue of November 2, 1824, edition of the National Intelligencer of Washington with an account of General Lafayette's visit to America; a skooter with one wheel missing and a few other odds and ends like that, to say nothing of 5 trunks full of clothes and 10 rooms full of furniture.

Men, women, and children had been streaming through the house all day. If it wasn't the electrician driving us crazy with his "one, two, three, four, Harrison speaking, one, two, three, four, Harrison speaking," as he tested the house intercommunicating system, it was the furnace man trying to get the bathroom to heat up to 80 in a hurry. If it wasn't the plumber pounding on pipes upstairs, it was the carpenter saying the new kitchen shelves couldn't be built that way, and Dick proving they could. If it wasn't the woman next door complaining that the new tennis court awnings cut off the light from her garage (and incidentally her view of the private lives of two famous movie stars!),

it was a 7-year-old youngster from the next block wanting an autograph.

The gas man had been there. So had a tree surgeon, the gardener, the bricklayer for the barbecue, the awning man, the insurance man, the telephone man, the drapery man, the rug man, the roof man, the floor man, and the laundryman. We were worn out with people and utilities.

The last of the men had been gone less than five minutes when the buzzer on the front gate sounded again.

"Jeepers creepers! There *can't* be anyone who hasn't been here today," Dick moaned. "We're just hearing things."

The buzzer sounded again. We were not hearing things.

"Who's there?" Dick roared into the dictaphone connected with the gate.

"Good afternoon," came the cheery answer. "It's the Fuller Brush Man!"

I didn't notice Dick had something in his hand. It felt like a cannonball but it turned out to be just one of Normie's sponge rubber toys. Anyway, I laughed. I forgot to duck.

And that's how I got a big black eye, a shiner terrific, a mouse that Joe Louis, himself, would be proud to hang on his next challenger.

Dick sent me two dozen red roses later to say he was sorry. But what I say is, the next time any one of my dear humorous friends asks me for "ringside seats," I'm going to really start moving furniture. Really!

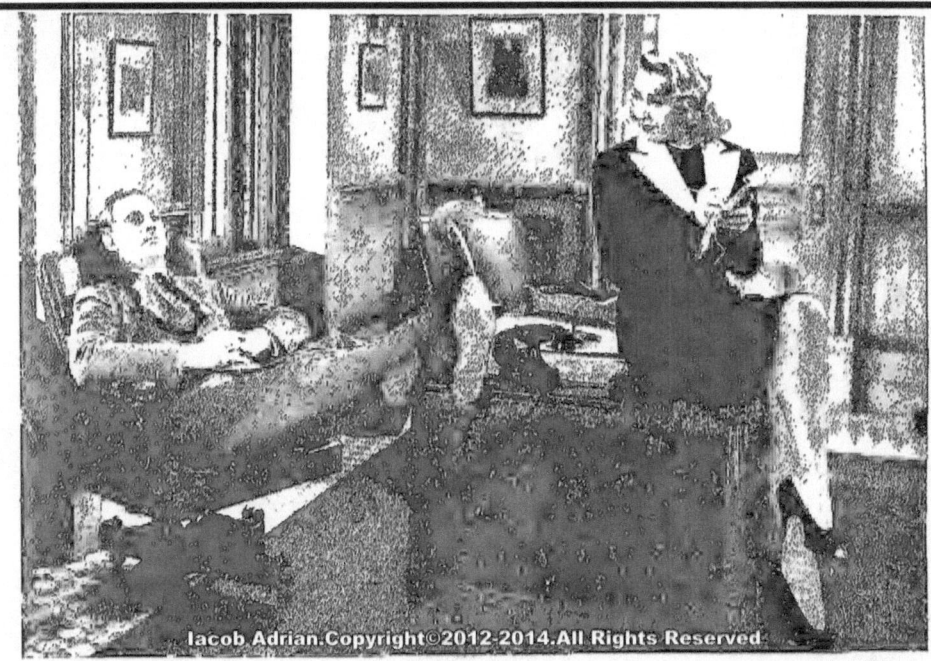

There comes a time in the life of every employer when his secretary decides to sit on the desk. Melvyn Douglas is trying to decide what to do about it while Joan Blondell waits to see what will happen. The scene is from Columbia's rousing new comedy, *There's Always a Woman*

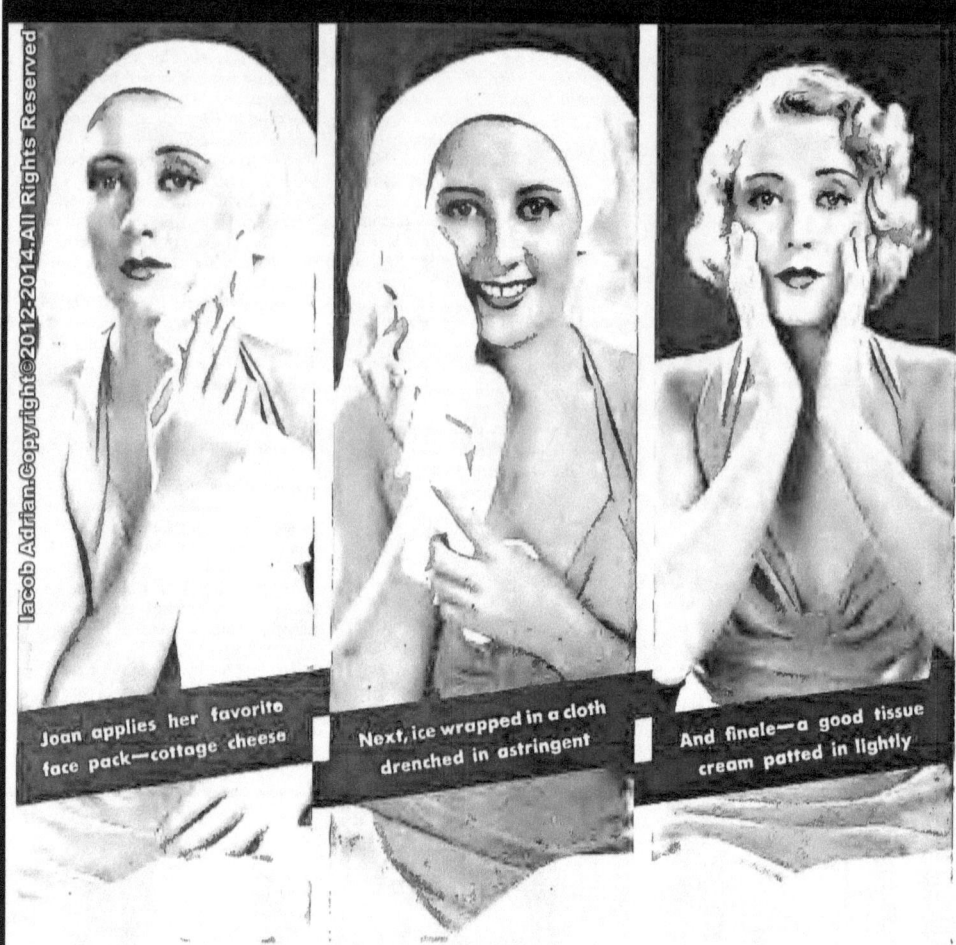

Joan applies her favorite face pack—cottage cheese

Next, ice wrapped in a cloth drenched in astringent

And finale—a good tissue cream patted in lightly

FACING IT

with **JOAN BLONDELL**

By ANN BOYD

JOAN BLONDELL, that delight-ful, effervescent blonde, has most original and interesting ideas on beauty and the care of the skin. Certain-ly she has that youthful pep and radiant beauty which we should all love to have!

She believes beauty is more than skin deep; that bodily health and wholesome thinking give the right foundation for a beautiful face—and yes, a beautiful complexion.

She believes character is expressed in the face and, if a strong, healthy, optimistic character is cultivated, it makes the problem of even skin beauty a simple matter!

Here are some of her secrets of youthful charm and beauty in her own words:

"Being the blonde type causes me to be doubly care-ful about my complexion," says Joan. "A brunette should have a clear skin and take care of her complex-ion, of course, but every tell-tale mark does not show on her face, as it does on the face of a blonde.

"The very first essential is health and cleanliness of skin. The face must be kept clean with packs, good old-fashioned soap and water, and with cleansing cream.

"If one uses a good complexion soap and warm water before starting to apply make-up, I believe there is no better way to cleanse the face. However, if creams have been used for cleansing for long, it will take a while for the face to become accustomed to soap and water.

"A good oily cleansing cream, the instantly melting kind, should be used, too, for a very dry skin in a dry climate.

"Diet is an inestimable aid in preserving and creat-ing a good complexion. Plenty of lettuce, raw carrots, spinach, fresh fruits, and not too much sugar, sweets or starches, will keep the blood fresh and the skin clear.

"With the constant use of

Facing It

cosmetics, as is the custom today, I consider it absolutely essential to use a good pack twice a week.

"My favorite beauty pack will give you a good laugh—and a gorgeous complexion. It is a bit of plain garden variety of cottage cheese—and milk!

"Smear over the entire face and neck—and yes, the hands too, as much cottage cheese as you can make stay on in a paste. Read or rest quietly until it is completely dry.

"Heat some milk to the boiling point. Soak a soft cloth in the milk and apply it on the face and neck. Gradually wash the cheese off with the milk. When the milk has been absorbed by the skin, pat the face dry. Then apply a turtle oil cream or just plain almond oil and pat it briskly.

"It is a good idea to give your face this treatment just before going to bed and let the oil stay on all night. Otherwise, remove the oil with a cotton pad soaked in a good astringent and pat it well into the skin.

"The patting motion is best for almost any application of cream or astringent.

"If I were to name the absolute essentials to milady's care of the skin, I would say:

"(1) A healthy body, gained by common sense foods and a light diet of simple proportions.

"(2) Soap and water, a good cleansing cream, oily and light enough to sink well into the pores, and plenty of soft tissues for its removal.

"(3) A thoroughly reliable tissue or turtle oil cream. This is one thing that is not sensible to economize on. A good tissue cream is essential.

"(4) A good, not too drying, astringent which will keep the pores closed and the skin fine-textured and makes an excellent powder base.

"(5) A not-too-powerful bleach, used occasionally to keep the face white and clean-looking.

"(6) A face pack at least twice a week.

"(7) Always have on hand a bottle of sweet almond oil. Pat the almond oil into the skin just before applying any bleach and after any pack.

"For normal complexions there is little need to do much but keep the face clean, with enough oil to counteract the effects of rouge, powder or climate.

"Of course, as one grows older the skin needs a bit more attention and care. Packs, muscle oils and rich tissue oils left on the skin all night are very helpful.

"I have always believed the reason for the fresh beauty of youthful complexions is that their owners do not worry about life; that their blood is kept racing by the romance and adventure that always seems just around the corner; and that living seems such an interesting thing that they cannot be bothered about the troubles that 'get under the skin' of older and more jaded minds!

"In short, my beauty formula, boiled down to a common sense basis, is take care of body health, adopt a normal, simple diet and use the simplest of facial treatments and cosmetics.

"If you follow this advice your face will have more than beauty, and your complexion will almost take care of itself!"

It's springtime in California, and playtime for lovely Joan Blondell. Her romance with Dick Powell is one all Hollywood looks on with approval

Come From Those

1. A foreign name
2. In a popular serie
7. Young and handsome
8. Leading man
9. He doesn't si

Out
Behind
Whiskers

Oh, so you think you are Sherlock Holmes, just like Joan Blondell? Since you're so good, turn those eagle eyes on this collection of crepe hair. Answers on page 61

6. Likes double talk

5. A good dancer

4. Noted for laughs

3. He is English

13. Great lover

12. Sure, you remember!

17. Give up?

11. He loves whiskers

16. You can't miss

10. This is easy

15. Funny man

14. Slender chap

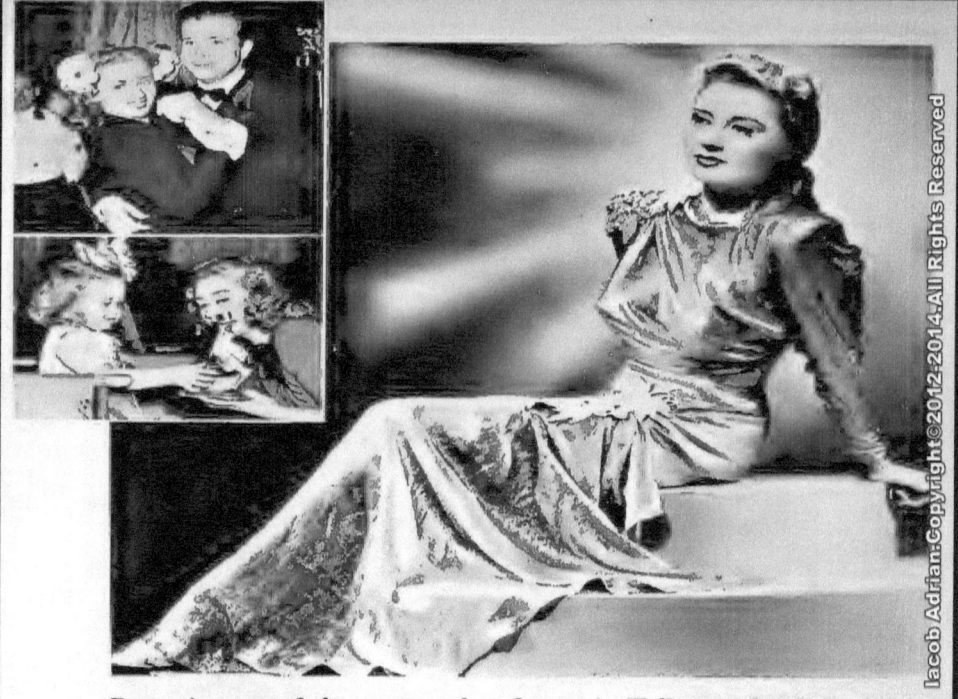

Possessing one of the most perfect figures in Hollywood has helped Joan Blondell win the title of America's Most Glamorous Mother for two consecutive years. Joan retains her youth and bubbling spirit by romping with her two lovely children, Norman, 7, and Ellen 2½ (above). Top photo: Joan and hubby, Dick Powell, enjoy a night out after tucking the youngsters in

America's Most
Glamorous Mother

By MAY DRISCOLL

■ "And now may I have my lipstick, please . . .?"

Joan Blondell was lying in bed in the hospital, pale and weary. Some hours earlier she had undergone the travail of giving birth to her second baby and now consciousness was coming on her. She had asked for the baby. And now her second request, of all things, was for her lipstick!

"You can't begin too soon," Joan said firmly. "A new mother must start in immediately taking care of her looks, otherwise she will find it so easy to get fat and frumpy."

For two successive years, Joan has been named the most glamorous mother in America by the American Mothers' Society of New York. To most women, harassed by the rigors of having borne a child and assuming the duties, the worries and coping with the psychological reaction that sets in, Joan seems to be some Miss Ponce de Leon. She seems to have some magic secret for looking so gloriously healthy and radiant in spite of (1) Normie, a little

Indian going-on-seven and (2) Ellen, a 2½-year-old little princess. Cameramen still clamor for a shot of Joan in a bathing suit, college boys still write her mash notes and she is always the bright and sparkling guest at any party. How Joan keeps her figure, her health and her glamour in spite of motherhood is not a matter of money or Hollywood beauty magic, but a formula that can be adopted by any young mother who has the will to be beautiful.

"For it's largely a matter of will," Joan told me. "As soon as a woman knows the stork is on its way, a group of reactions set in: fear, joy and a lingering sense of martyrdom. It's that last that is destructive. When an expectant mother begins to excuse her sloppiness and listlessness on her condition, then she's headed for trouble. The time to start to rebuild your slim, rounded girlish figure is the very moment you are sure you are going to have a baby.

"A prospective mother must make up her mind to devote a year and a half to her

baby and herself. She must determine never to let up, but to turn every single moment to use. For instance, during the latter months when my activities were more confined, I passed the time by trying to beautify my hair which I never thought was thick or glossy enough. I brushed it for long periods, tried new tonics, experimented with new hairstyles that I never had the time to do before. After the baby was born my hair was actually lovelier than it had ever been, instead of falling out as happens to many new mothers. If other women would do the same—select a feature they don't like and try to improve it, instead of whining about their confinement—they would find a definite beauty reward in the end.

"I went by the rule that an ounce of prevention is worth a pound of cure. Just because Nature was about to distort my figure was no reason for me to sit back and do nothing about it. I wouldn't let a corset do the work of my stomach muscles. I always made a conscious effort to stand straight and pull in my abdomen during and after the period. This strengthened the stomach muscles so that after, my babies were born, I was just as slim and supple as a high school co-ed. Such continued diligence can give any woman an even better figure than she had before her baby was born.

"I held on to my vanity as though it were the most precious trait I had, for that prodded me into making a Spartan effort to keep my looks. I wouldn't let myself get fat. True, my figure looked like the devil after a while, but there was no reason to

make matters worse by eating candy and putting on excess weight. When I had a craving for food—and how often that was! —I was a good girl and munched vegetables, or sipped meat broth and the like. I didn't stuff myself. I ate for strength, not for fat.

"I wore pretty, clever dresses, not any old thing, and I continued to fuss with my hair and my make-up as I had done before. Once you get out of the habit of looking your best, you may lose the desire completely.

"My activities were limited, but not eliminated. I went out and enjoyed myself as much as I could. It's good to socialize and keep busy, because happiness is a great beauty tonic in itself.

"So then I had my baby. I was so thrilled and happy! Dick was beaming but I wanted him to be proud of me too, as well as that pink and white baby. Several times I began to feel sorry for myself. It was a natural nervous reaction, but I snapped right out of it. I determined not to let myself go. Millions of women have had babies—what I wanted to do was to have my baby and my looks too. I kept up my diet, and as soon as I was able to I went in for a regime of exercises to strengthen the muscles that had been stretched.

"There are so many ways to turn so-called liabilities into assets. It all depends upon knowing how. Even though your babies are wild little Indians who tear about the house, you can let them make you younger, instead of a nervous wreck. Don't ever let your children get on your

nerves or wear you out. As soon as you find yourself getting irritable around them, leave them until you're relaxed again. Learn how to play with them. Relax with them. Laugh with them.

"Instead of bringing up my two hopefuls to think of me as a frowning adult who is forever saying 'Don't', I am a playmate of theirs, growing up with them. Have you ever watched a child? Ever notice how often he laughs, the unbounded enjoyment he gets out of new discoveries? In order to be a playmate of my children, I must meet them on their level. I must laugh with them, be alert to new discoveries just as they are. A child's laugh is contagious, and my children have given me a young, bubbling spirit. I joke with them, make funny faces with them, play in the open with them, and I'm growing younger all the time. Because of association with them, I have retained my enthusiasm, I have developed a great fund for enjoying myself. Small joys are wonderful youth preservers, and young mothers have an opportunity to get them.

"Once, when Normie saw me dressed up to go out, he looked at me proudly and said, 'You're so pretty, Mother.' That delighted me. I want my children always to be proud of me. Ellen imitates me and my fastidiousness is an example to her. She keeps her nails clean, her hair brushed because I do. So, you see, a mother just must be attractive. Her children force her to look her best.

"And that's the difference between being just a mother—and being a glamour mother." ∎

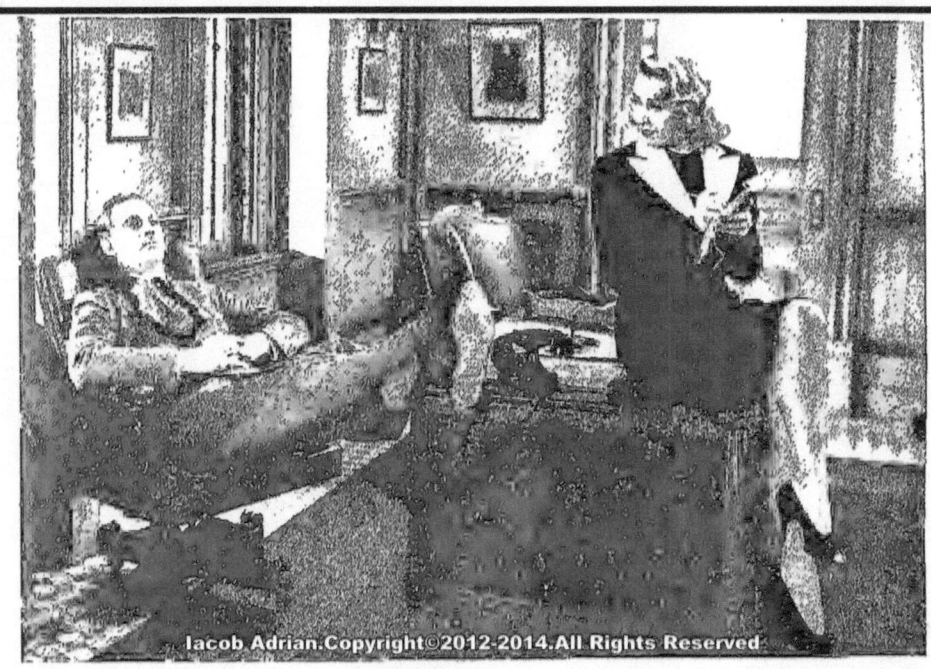

There comes a time in the life of every employer when his secretary decides to sit on the desk. Melvyn Douglas is trying to decide what to do about it while Joan Blondell waits to see what will happen. The scene is from Columbia's rousing new comedy, *There's Always a Woman*

JOAN BLONDELL, the Warner Brothers-First National star, is a little tornado who has swept across Hollywood and scored one success after onother. Her first starring picture was "Miss Pinkerton"; her current release is "Big City Blues."

The NEW MOVIE Magazine's
GALLERY of FAMOUS FILM FOLK

HOLLYWOOD
BANDWAGON

Jack Oakie tells the story that when Gary Cooper was in Africa, he was feasted by a native chief and when the meat course appeared, Gary asked, "Is this gnu meat?—The chief answered courteously—"No, but it's just as good as gnu!"—Gary laughingly denied the story, so Jack said—Well, it's *still* a good story.

RADIO PICTURES have been making "Kong" for more than two years and they are extremely anxious that no publicity leaks out until the picture is completed. All of the scenes have been taken behind closed doors and every actor in the cast has been sworn to absolute secrecy.

Of course, there are plenty of rumors, chief among which is the one about the pre-historic ape more than twenty feet tall around whom the story is supposed to be built. It is pretty certain to be a big thriller. Edgar Wallace wrote the story, the last manuscript before his untimely death.

DID YOU KNOW

THAT a producing company is making a series of bridge short features with a well-publicized bridge expert and that same expert is giving them plenty of trouble.

That Katherine Hepburn, who leaped to fame in "The Bill of Divorcement," was actually scared of publicity when she came back to New York and insisted that she would wait until she was a success before there would be any pictures taken.

" 'Twas the night before Christmas, and all through the house," Jackie Cooper envisions the jolly old friend of the yule-tide season. What a dream!

Lovely and vivacious Joan Blondell will soon be made a star by Warners. Maybe that's why she is so happy.

THE

It's a matter of
LIFE and DEATH!

CROWD ROARS

Starring!

James **CAGNEY**
Joan **BLONDELL**

with

ANN DVORAK
ERIC LINDEN
GUY KIBBEE
Story by
Howard Hawks and
Seton I. Miller
Dialogue by
Glasmon and Bright

Direction by
HOWARD HAWKS
of "Dawn Patrol" fame

Speed demons with goggled eyes glued on glory...Grinning at death...laughing at love!...Breaking necks to break records— while the Crowd Roars—FOR BLOOD!...Never —never—never has the screen shown such nerve-racking ACTION—lifted right off the track of the world's greatest speedway! It's the thrill epic of all time—the talk of every town that's seen it...Forty men risked death to film it. Miss it at your own risk!

12 of the world's greatest race drivers in the most thrilling action pictures ever shown!

She fought for her man— with every trick love knows!

THE HIT of the **YEAR** - FROM WARNER BROS.

Joan's Hollywood Home

LOW and rambling in the true California style is this lovely home of Joan Blondell, lovely film star and her husband, George Barnes. It started out to be quite a small house but now that a Joan or a George junior is due to arrive a very private little wing was added to be his or her very own.

The plan of the house is quite unusual and interesting. The living room is large and square with a big open fireplace and a windowed nook which gives a wonderful view of the lovely California mountains. Then there is the small library and the bar and playroom with its little corner fireplace. The dining room is exceptionally large and has plenty of wall space, the kitchen is small but is conveniently arranged and complete in every detail. The main portion of the house contains two bedrooms each with a connecting bath, one on the first floor and the other upstairs.

The new little wing is a small apartment in itself

The Hollywood Hills home of Joan Blondell, lovely film star, and her husband, George Barnes, is situated on beautiful Lookout Mountain

containing a bright and sunny living room, a tiny kitchen for preparing baby's meals, a bedroom and a bath.

The architectural style of the house is of the early California Spanish type. It is situated on the south slope of the Hollywood Hills on Lookout Mountain and has, without a doubt, one of the most beautiful views available in that section of the country. The exterior is constructed of whitewashed brick topped by a shingle roof. The bright blue shutters and cunning little iron balconies give an appearance of gaiety and informality to the house.

Joan loves flowers and likes to see them grow, which is quite evident in her lovely garden. Shrubs and plants of all kinds and colors occupy every available space and Joan takes care of them herself.

The interior decoration and furnishing of this little house are most expressive of Joan's own personality. The color schemes are bright and cheerful, the furniture is simple and comfortable and the entire atmosphere of the house is cosy and home-like.

Like a great many of the movie stars Joan was her own decorator; she also worked with the architect on the plans of the house while it was under construction.

Do you like Joan Blondell's house? We should like to know what you think of it and we should also like to know what other stars' homes interest you most and which ones you would like to see in pictures and plans. Send your comments and suggestions to Tower House Editor, in care of NEW MOVIE Magazine, 55 Fifth Avenue, New York, N. Y.

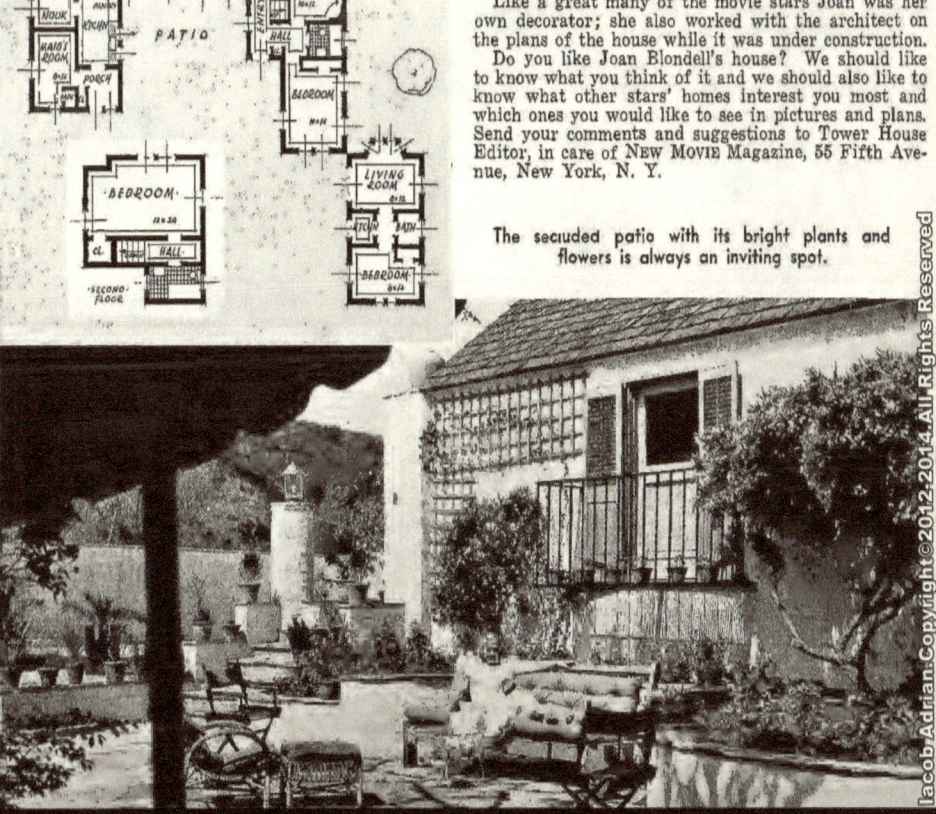

The secluded patio with its bright plants and flowers is always an inviting spot.

MOTHERHOOD FOR
JOAN BLONDELL

Will she leave the screen? "If I do, it's worth it!" says Joan.

By
EDWIN
SCHALLERT

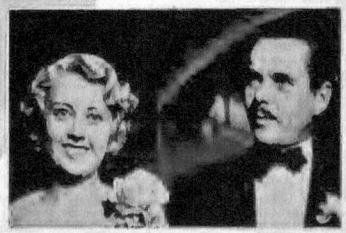

Joan and her husband, George Barnes, have always wanted a baby. Joan meets motherhood with courage, reverence, and deep, undying thankfulness.

N O matter what happens, my baby will come first. I don't care what motherhood does to me. If I have to quit the screen that will be all right. In fact, it would be a big thrill to start all over again—to live in a two or three-room apartment, if necessary, and to handle the housework and the cooking and everything else. No, prospects of a change, because I am going to have a baby, regardless of how terrific they may be, do not frighten me at all. I have no patience with fear."

Joan Blondell was standing on the brink of motherhood when she made this statement to me. And in Hollywood it is a "dread brink"—ask any star! Even more so maybe than in the rest of the world.

Joan was fearless, strong, calm. Her personality radiated vitality, serenity and courage. She has been through troublous early days, foreshadowing the approaching event. She was just about to retire from studio work for an indefinite period. She had planned to leave the films in plenty of time—taking no chances on any complications that might ensue from her continuance of film activities with their strenuous and often drastic physical demands.

"My baby is the only one who deserves the 'break' under these circumstances; I shall not now or later do a thing to risk his health, happiness or welfare," she continued. "Possibly I could make another picture, but it is not the safe thing to do. George has a vacation

and we shall travel for a while. I want to see my sister in Detroit where she is playing in 'She Loves Me Not.' Then we may go abroad. We thought of a voyage to Tahiti, but have abandoned that. We can't risk that adventure. We'll see the South Seas some time later when our youngster is able to accompany us. And how proud we'll be to have him—or her—with us!" she exclaimed.

Maybe you know Joan Blondell; maybe you don't. I mean her "inner self." She has been a trouper every step of the way—since early childhood. She never flinches; she takes every task as it comes; nothing ever devastates her or causes her to become temperamental —that cardinal sin which seems almost the key to success in Hollywood. Instead, she is always *there*, and dependable.

In all my experience in Hollywood I've never known anyone to be quite so sincerely joyous, sensible and very much like "folks" the world over in her attitude about having a baby as Joan Blondell. She views it simply as the natural, the expected thing. No flub-dub! Nor is her first the only child Joan anticipates. She is considering others.

"If this first child is a girl," she said, "I will name her Joan Barnes. They didn't want to let me take that name at the studio, you know, when I wanted to. So I may have my chance to use it now in a different way. If it isn't a girl this time, well

Motherhood for Joan Blondell

then . . . maybe the next time," she smiled. "Anyway some day there may be a Joan Barnes." And if Joan does achieve this particular christening, she will be fulfilling an ideal that she has always had, namely merging her own with her husband's name, even though it must be done through a daughter. She has wanted many times to assume the name herself, but it is felt that Joan Blondell has box-office value, whereas Joan Barnes hasn't.

JOAN has other ideas about the future, some of which she may put into effect after she returns to the screen, probably next Spring. One is about the number of pictures she should make. "You know I've been appearing in films at a rapid pace ever since I came into the movies," she went on. "I haven't been living my own life at all. Just work, work, work, all the time!

"Never have I chosen any stories for myself, or tried to acquire glamour or put on the ritz. Probably I never will.

"Anyway, I'm hoping to change things in many ways. Especially I don't want to make so many films in the future. I would like to limit the number to about four a year. I simply can't do eight and nine as in the past. It takes every bit of one's time, and I certainly will not have a baby and see it just now and then, and off and on, which would practically be the case if I went on as heretofore. Why, if I couldn't be with my baby a lot, I would leave pictures. They don't mean that much to me personally. I can't feel about them as some people seem to do, that there is nothing else in the world besides this. Why if it comes right down to it I can drop right out, and we can live on George's salary as a cameraman. Goodness knows, I've lived on a whole lot less than that before now.

"HOLLYWOOD appears to be under a sort of spell of fear. Everybody shivers over something or other. They dread to lose their places in pictures; they dread poverty, dread this, and dread that. It drives so many of them frantic seemingly. They wonder what tomorrow will bring, and they cease to live in a big and true way.

"I've been looking over my past life, and thinking about things. I suppose all expectant mothers do. We reflect about everything that has happened. Especially I get to considering this fearful attitude that is so much in evidence here, and that seems to be such a part of this business, and it really is a business, rather than the theatrical profession I used to know. Why, can you believe it, we never had any worries like that when I was a child! You know, I was raised in the show business, born in it as a matter of fact, and we were the most happy-go-lucky lot imaginable, my father, my mother, my brother, sister and myself. We never took anything seriously. Of course, most of the time we made good money, but we had our bad days too, and as I remember it we were just as cheerful during the one as during the other. Bad days never got us down.

"It's funny how they've painted my childhood in the stories written about me. They've said that I endured all kinds of hardships and privations, giving the impression I was half-starved. It's ridiculous. Nobody had a happier girlhood. I was given the best, and had much more in the way of experience.

"Think of the travels of those early days! We went everywhere. I had my first birthday in Germany, my second in Paris, my third in Sydney, Australia, and my fourth in New York, one or two in this country following that, and then my seventh in China. What a thrill for a youngster! It taught me to meet all kinds of people, all over the world. If I've learned anything about acting or characterizing it all goes back to that. You have to form your impressions quickly when you are constantly on the go, you get to know people almost at a glance.

"PERSONALLY I would not be afraid to set out all over again, just like that, with my husband and baby. In fact, it would be a lot of fun. I guess we could get up a vaudeville act again between us, and carry on the Blondell name, which was a grand name in the theater anyway. Or maybe we'd go out as the Barnes troupe instead.

"Under such circumstances, how can I feel upset about the future? I suppose motherhood is a serious thing to face, and I know it isn't easy in any sense of the word, but I feel, too, that my life would be frightfully incomplete without the experience.

"What's more, I think I have a real love for the domestic side of life. You know, we always were a clannish family. We had a lot of happiness just being together, and that's the thing that counts. When my sister left us to go in that stage show in the East we all wept. It amounted to breaking up our little group. My mother and father, and my brother and his wife are out here with us now. We were always together, and we always believed that we had a home, whether it was in a wardrobe trunk, or a nice white house on a shaded street.

"Yes, there were houses too. We didn't always stay in the show business. There were times when we tried desperately to get out of it. Father felt that the family should settle down, and that his children should have the chance to meet nice townspeople, and stay in one spot and get married. This notion would come to him every once in a while, and then we would purchase a business with the money we had saved during our vaudeville tours.

"Down in Denton, Texas, we had a store for ready-to-wear clothes for a time. We did very well there, because we were right opposite a college, and the students came and bought from us. We were just getting nicely started, and then suddenly the college announced a rule that the girls who were attending would have to wear blue middies and skirts exclusively, and we were left with a big stock on hand and no place to sell it. So that venture failed.

"Once, too, we opened a tea room in Santa Monica, right on Wilshire Boulevard, coming pretty close to the films, and we operated that for six months. We felt we were quite successful in that enterprise. We built up a very good business, and not picture trade either. The only movie person who actually came there was John Gilbert, and what excitement he caused. I waited on him myself, and I was tickled to death when he gave me a tip, and kept it as a souvenir. He brought a very beautiful blond girl with him to our establishment, though I don't know to this day who she was.

"You'll laugh when I tell you that we finally went broke in this enterprise, and the reason. My school friends ate up all the profits. They were forever coming to the cafe with me and literally devouring us out of house and home. If they so much as peeled a potato to help, my mother would give them a whole meal.

"Besides, we had no understanding of book-keeping, profits and losses, the amount of money we were spending on supplies as related to what we were taking in, and all that sort of thing. We made the terrible discovery, though, on a certain day when Father went to pay the meat bill. I guess that none of us realized how much meat was costing us. Anyway, Father went down to the butcher shop to pay up, and before very long we heard from him over the phone. He told us that we were going on the road again, much to our astonishment. He said that he had just managed to book the act by phoning my agent in Los Angeles. He informed us that we were to close up our eating place before it put us all in the poor house. He said that we owed the butcher enough to bankrupt us, in fact we couldn't pay him at all, but would have to send him the money after we had gone out on tour. He had arranged to extend our credit until then. So that's how we quit our restaurant business.

"Yes, I've looked back on all those adventures, and thought how happy we were, and the future doesn't make me the least bit worried. I recognize this as a turning-point, naturally, but I'm not upset. The future, when I consider it at all, is just as bright as it ever was back in those joyous carefree days.

"I haven't made any special plans. I'm not the kind who does. If this is a crisis in my career I refuse to regard it as such. After all, millions have gone through this before, and so why not I? Anyway, if you worry one day about what is going to happen the next there is not much fun in living. It would not be a blow to me at all if next year I were thrown out of pictures.

"George and I have a lovely house, and it's just about all paid for too. Personally, I've settled down as much as I ever expect to. I'm almost a homebody now, even though it's been a fight to become that. Why when I first arrived in Hollywood I thought I would go crazy staying in the same place all the time. I moved from house to house on an average of about every two or three weeks. I think I lost more money on advances paid on rents than I could make up in a year.

"I'm not over that restlessness yet. It hits me every once in a while. George has the same spirit too. That's why we're making these plans for travel now. And do you know what we did just the other day? Not satis-

Motherhood for Joan Blondell

fied with our beautiful house and all, we had to go out to look at a ranch. We live in Laurel Canyon, where it is sort of out in the open. But that isn't enough. We must price a ranch too—probably just to get that desire for a change out of our systems.

"Maybe the arrival of our baby is going to alter our lives completely. I sometimes wonder. Maybe we'll never budge again, and feel terrible responsibilities and all that; but so far nothing has ever killed the easy-going spirit that all the members of our family possess for very long. We just are that way; it's probably the old vaudeville spirit, and there's no telling but it will stay with us to the very end of our lives."

AND that's Joan, on the eve of motherhood, the great problem and perplexity of Hollywood, the thing that day in and day out keeps more stars worried than any other, if the truth be told about it. Children are born and reared in the movie colony, and fair ladies of the screen enter into the adventure with all manner of moods and sentiments regarding the future, but few inspire one more with their viewpoint on the whole expedition than Joan Blondell, and none has embarked upon it more blithely, joyously and happily than she.

Rudy Vallee and his pup look pretty pleased with themselves. Wouldn't you, if you had just signed a five-year contract with Warner Brothers? His first picture will be called "Sweet Music."

It's springtime in California, and playtime for lovely Joan Blondell. Her romance with Dick Powell is one all Hollywood looks on with approval

Bibliographic sources :

Hollywood (1934-1943)
Publisher: Hollywood Magazine, inc. ; Fawcett Publications, inc.

The New Movie Magazine (1929-1935)
Publisher: Tower Magazines, inc.

This documentary study use,
combined in various proportions,
elements from the following categories,
forms and subsets :
- fair use
- documentary
- documentary photography
- feature
- journalism
- arts journalism
- visual journalism
- photojournalism
- celebrity photography
in order to :
- employ material as the object of cultural critique ,
- quote to illustrate an argument or point ,
- use material in historical sequence,
providing independent opinion,
using photos, press articles, advertisements,
opinions of fans etc. ...